# A TOULOUSE-LAUTREC ALBUM

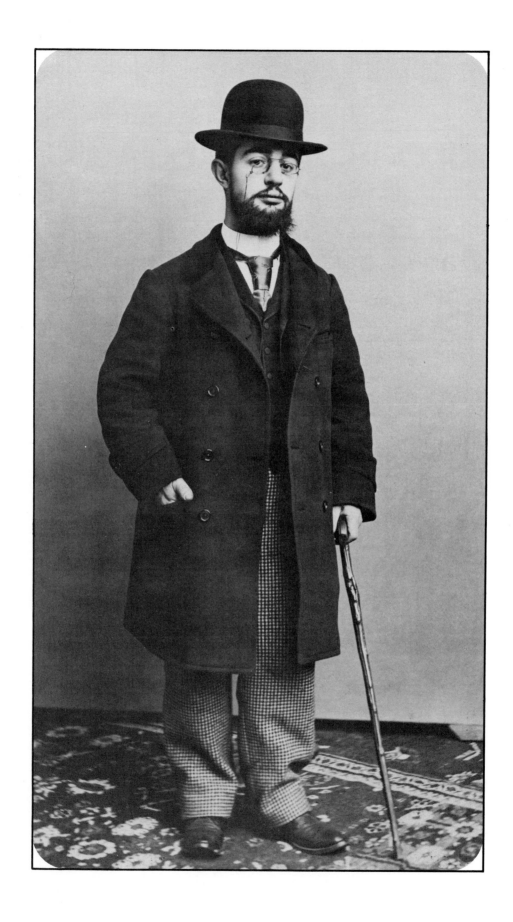

# A TOULOUSE-LAUTREC ALBUM

Edited and Compiled by Georges Beauté

Captions by Mary Tapié de Céleyran

Epilogue by Robert de Montcabrier

Gibbs M. Smith, Inc.
Salt Lake City, 1982

**Translated by**

**W. Michael Lovett**
**Mana Derakhshani**

Copyright © 1982 by Gibbs M. Smith, Inc.

**Library of Congress Cataloging in Publication Data**

Beaute, Georges.
  A Toulouse-Lautrec album.

  Translation of: Il y a cent ans, Henri de
Toulouse-Lautrec.
  1. Toulouse-Lautrec, Henri de, 1864-1901.
2. Painters—France—Biography. I. Attems, Mary,
comtesse. II. Title.
ND553.N7B413  1982    760'.092'4 [B]    82-16831
ISBN 0-87905-127-2

Book design by Adrian Wilson
Manufactured in the United States of America

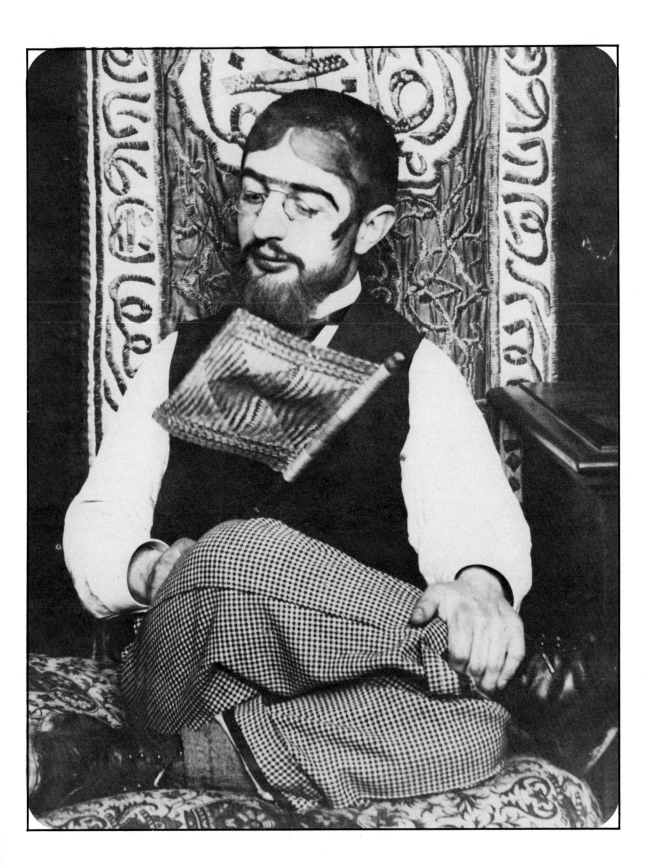

## Acknowledgement

The author wishes to thank the following for their assistance:

The Tapié de Céleyran du Bosc family
Madame de Vignaud de Villefort, daughter of Gabriel Tapié de Céleyran
Edouard Julien, curator of the Toulouse-Lautrec Museum
M. G. Dortu, chairperson of the Societè des Amis du Muse d'Albi
Ronald Searle
Madame Lejeune, daughter of Maxime Dethomas
Madame Clerc-Mirande
Georges Séré de Rivière

# A TOULOUSE-LAUTREC ALBUM

Adèle-Marquette Tapié de Céleyran was born in Narbonne, 23 November 1841, the daughter of Léonce de Tapié de Céleyran and Louise D'Imbert du Bosc. She was still very young when she married her first cousin Count Alphonse de Toulouse-Lautrec. This unfortunate inbreeding must be mentioned here, as the couple's son Henri would be its innocent victim.

Young Adèle is remembered as a pleasant girl, fair of complexion, even-tempered, and of refined education. She was raised in the ostentatious household of old Céleyran and put into the care of an enlightened tutor, M. Imbert, who nicknamed her "Flower of Paradise."

She would lose her head only once in her life, and she would have cause to regret it. Her son would later say, with tender malice, "My mother, virtue itself . . . but she couldn't resist a uniform." Putting her trusting hand into that of a handsome officer soon disillusioned her, since this romantic marriage became a disaster, forming an insuperable abyss between a quiet, conservative, and well-balanced woman, and a nobleman who, although charming, was extravagant and inconsistent, totally unable to maintain in his house the peace of conjugal tranquillity.

Alphonse de Toulouse-Lautrec Montfa, son of Count Raymond (called the Black Prince) and Gabrielle du Bosc, was born in Albi, 10 August 1838. His first education was at his mother's knee. Later, he studied under the iron rule of various tutors and for a few months at a Catholic school in Cordes. At last he finished his education with the Dominicans of the School of Sorèze where Father Lacordaire, a demanding master, loved him but ruled him with severity. He was brilliant but impulsive, and passionately fond of sports—all sports—a family trait. At the mere mention of riding or hunting, he would toss aside his books and work.

However, despite these whims he was an extremely gifted student and passed his exams before entering Saint-Cyr, the national military school for officers, admittedly without much enthusiasm. For him it was a cage, and he hated all cages, even gilded ones. He made himself known for his elegance and carefree manner combined with an independence which recognized no limits. Except for matters of honor and respect for tradition, upon which he was uncompromising, the army for him was nothing but a club for amusing himself, having fun with his comrades, and giving himself wholeheartedly to his pleasures. He leaped beyond the reach of all discipline, always his pet aversion. Still, he fell into a trap when he let himself be snared by the charms of his cousin Adèle, an heiress and a very attractive catch. He married her, sincerely convinced, as was she, that their union would be a happy one.

Here the drama began, for no woman in the world could tame Count Alphonse. Almost immediately, the newlyweds found themselves in disharmony—she lucid and practical, he, giving full rein to his impulsive nature, careening on a course not even a Valkyrie could follow.

Two sons were born: Henri, in 1864, and Richard, in 1867, who was only a brief visitor in this world. Certainly, Alphonse was happy to have a son, but lullabies and nurseries were just so much silliness to him, and the child would only become interesting to him on that day when he could proudly put him on horseback.

Alfonso de Toulouse-Lautrec Montfa, hijo del Conde Raymond (llamado el príncipe Negro y G. du Bosc. Nació en Albí el 10-7/1883. Su primera educación fue en las rodillas de su madre. Más tarde estudió bajo la regla de hierro de v/tutores y por pocos meses en la Esc. Católica en Cordes. Finalmente terminó su educación con los dominicanos en la Esc. de Sorèze su prestigioso maestro lo quiso pero sin dejar de manejarlo con severidad. Era brillante pero impulsivo, apasionadamente inclinado a todos los deportes, un rasgo familiar. Al solo mencionar paseo o caza él dejaba los libros y el trabajo. Sin embargo, a pesar de estas ligerezas el era extremadamente talentoso y pasó sus exámenes antes de entrar de la Escuela militar, aceptado con su mucho entusiasmo. Para el esto era una jaula y el odiaba todas las jaulas aun fuesen doradas. El se dio a conocer por su elegancia y despreocupada manera combinada con una independencia la cual no reconocía límites. Excepto por conceptos de honor y respeto a las naciones por lo cual era era inflexible, el ejército no significaba nada para él

14

Henri Marie Raymond de Toulouse-Lautrec Monfa came into the world 24 November 1864, in the Bosc family house, a veritable mansion in Albi (Tarn), his paternal grandmother's estate. He was born during a violent storm, and his birth endangered the life of his young mother.

He was a normal, healthy baby, baptized with all the ceremony befitting the firstborn son of a firstborn son. He was christened Henri for Henri V, the Count of Chambord, the last descendant of Louis XV, who was then the hope of the "legitimists," who were working for the reestablishment of the Bourbon succession.

His father and mother did not conceal their joy and had no trouble imagining the beautiful life awaiting this newborn son who found, from his cradle, all that a human could wish for.

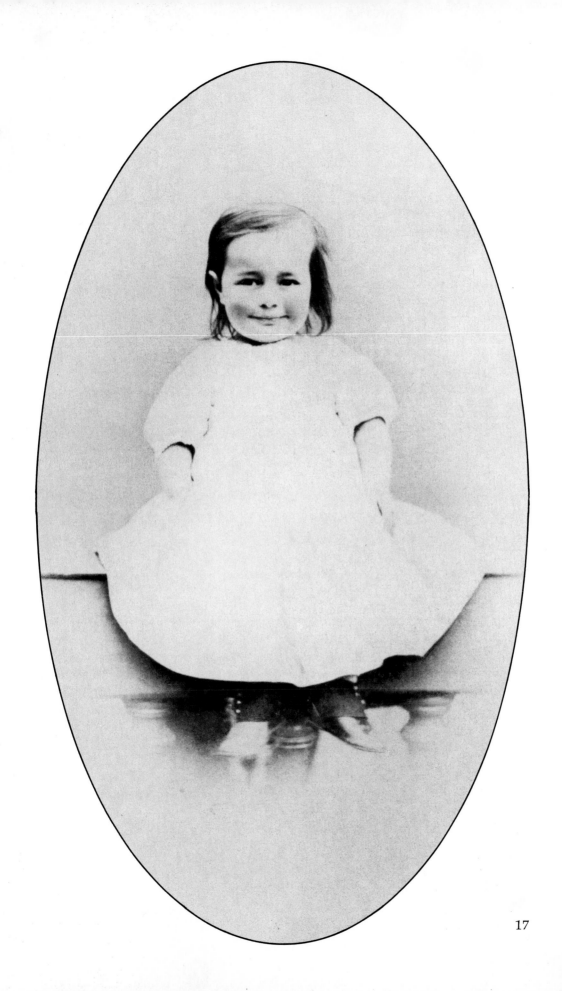

The young mother pampered Henri and dressed him like a doll in fashionable clothes. Here he is dressed in a Spanish-style costume of white cloth embroidered with multicolor braids. Family and friends exclaimed, "The Alphonses really have a wonderful little boy." The only nickname given to him was "Little Jewel." It fit him.

Count Alphonse lost patience with all these slightly effeminate frills and impatiently awaited the time he'd be ready for the first pony. Boots and a riding crop—that's what suits a man, especially if he's a Toulouse-Lautrec.

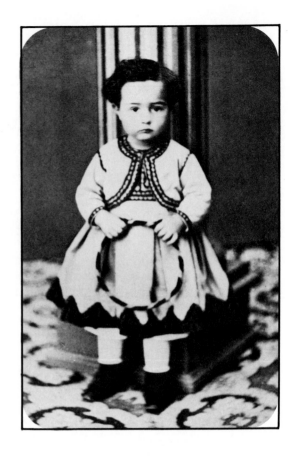

Henri had one of the best names in France, a great deal of money, and much property. A precocious intelligence revealed itself with his first words, and he showed an extraordinary gift for drawing. At the baptism of his first cousin, Raoul Tapié de Céleyran, when he was about four, he was too young to sign the sacristy register: "Well," he said, "put me on a chair and I'll draw an animal."

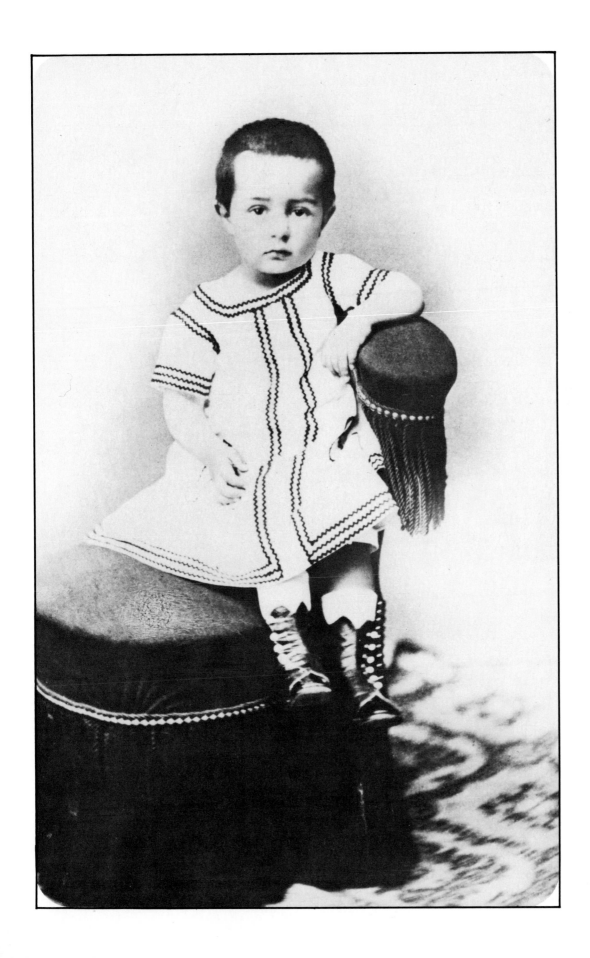

This is Lautrec's preferred childhood photograph which he identified as Baby "lou poulit," "pretty one" in patois, a dialect of Southern France.

He had good reason to be pleased with himself: delicate and well-proportioned features, profound and luminous eyes which he inherited from his father and which would later remain his only beauty, and a small, plump frame. His gracefulness and charm impressed those around him, and he was the envy of mothers who saw this exuberant, active little boy in perfect health.

At his Uncle Odon's house in Brittany, he herded cows, something which he called "smashing fun." And when he went south to the lagoon of Arcachon, about thirty miles west of Bordeaux, he was delirious with joy: "I've already taken twenty-two swims. We climb the trees to jump onto the second-story balcony where my mother is." But the most wonderful of joys was "to get up on horseback."

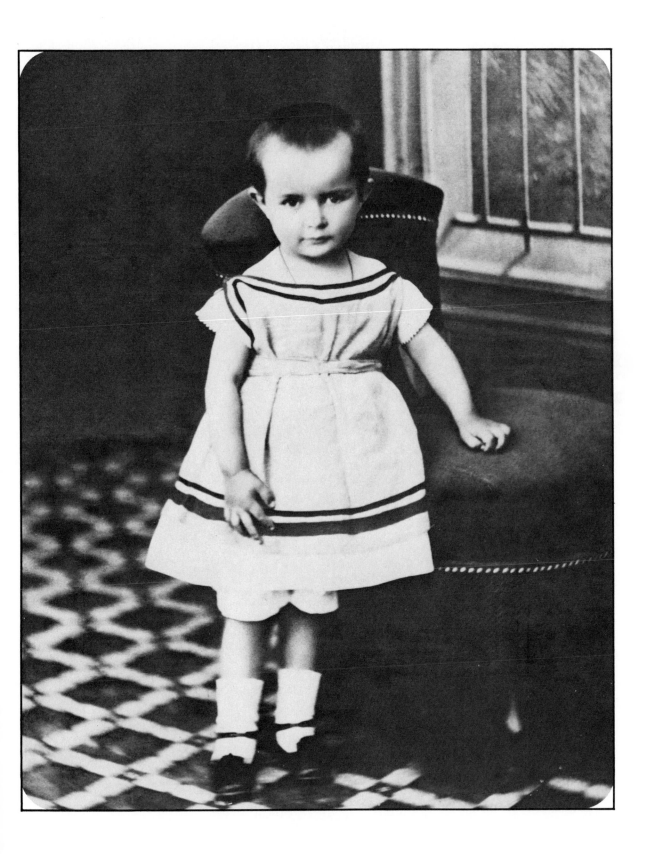

With Queen Victoria on the throne, anything English made a stir, and the Lautrec household was no exception. Henri was costumed like a Scotsman with his kilt, a jacket fitted with gold buttons, and a little cap.

A little man, he poses seriously, proud of his suit which he called "fashionable."

During this period, he started a stamp collection and spent winters on the Riviera with his mother. Here he gained an everlasting love for all things pertaining to the sea.

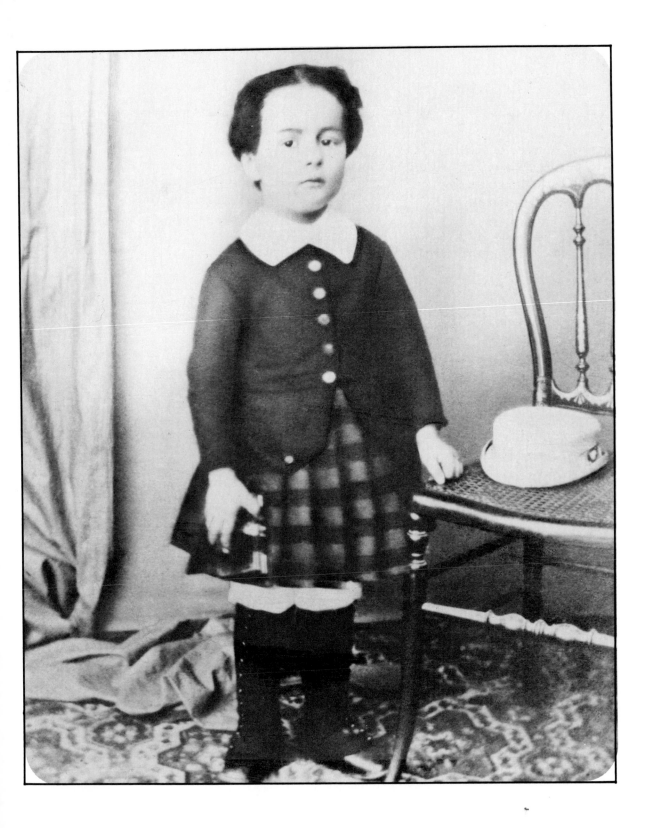

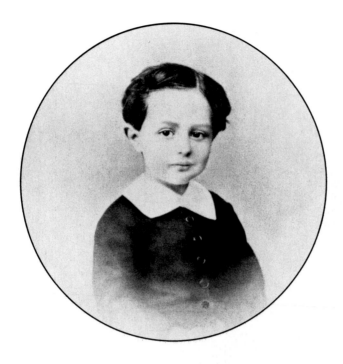

What a charming countenance this little five-year-old had! And what an enchanted life was opening before him: winters under the beautiful Mediterranean sky, summers upon the lawns of Bosc.

Cousins gathered under the wand of this gentle magician who led the games.

Who rode his pony Tambour (Drum) most skillfully?—Henri! Who improvised all the comic and dramatic scenes in the puppet theater?—Henri. Who invented and told the most beautiful stories?—Henri, always Henri. But who was also the most troublesome? The leader of the pack?—Henri. His male cousins admired him; the girls adored him. Often punished but always forgiven, he was a lovable little devil who became angelic whenever he wanted to "comfort mother."

After this beautiful childhood in the fresh air came school years beginning with first form at Condorcet. These years were all too often disturbed by Henri's ill health and the unstable atmosphere of the Toulouse-Lautrec household, which was constantly traveling between Paris and various locations.

Henri had tutor after tutor. When none could be found, the ever-vigilant mother filled in, feeling perfectly capable of raising a boy.

But whether on school benches or elsewhere, Henri covered his notebooks and the margins of his books with a cloud of drawings, rapid sketches—an art of abridgement and synthesis. With his agile pen, he reproduced everything he saw, everything which amused or pleased him—in horses, hounds, falcons and riders, scenes of hunting. His sense of humor expressed itself in caricatures which were not always charitable. Even then he had a biting wit.

All children scribble with more or less felicity, but Henri's art showed the emergence of an astonishing personality.

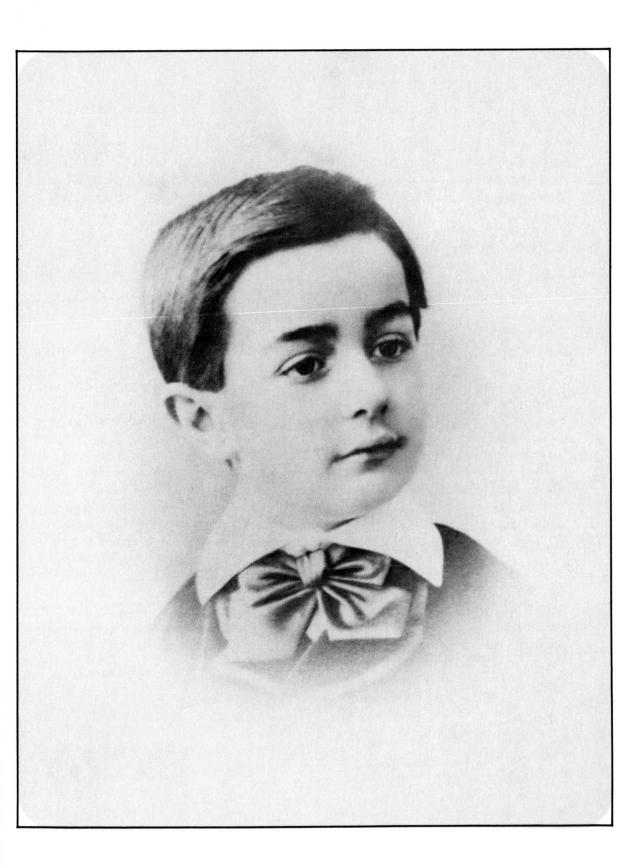

But a great misfortune occurred on 30 May 1878. In the salon of the Bosc house, thirteen-year-old Henri rose suddenly from his chair, tripped and fell, breaking his femur. Not a serious accident for most people, it was tragic for this child of first cousins and signalled the end of his good health and the beginning of an invalid's pilgrimage from one watering place to another, from one treatment to another, from doctors to specialists.

Two years later, at the Bareges spa in the Pyrenees, he would fall again, breaking his other femur at a time when a slow but certain recovery from the first injury was expected. This second fall would stunt his growth and condemn him to remain forever crippled and deformed.

He refused, however, to wallow in self-pity and retained his vivid interests. This magnificent portrait was taken in Nice at the studio of the photographer Echtler. Henri and his mother were again wintering on the Riviera where Henri was charmed by his young teacher "because he owns a boat that will run in the Cannes Regatta." Too young to enter the gambling casino in Monte Carlo, he gave his piggy-bank money to an adult friend who doubled his stake.

A painful physical transformation can be seen in this photograph. Not only was Henri reaching the awkward teenage years when nearly all adolescents lose the gracefulness of childhood, but Henri virtually stopped growing or, rather, which was worse, his legs did not grow with the rest of his body. His long torso and stunted legs would create a jarring contrast. His face was maturing too early. A shadow of moustache shadowed the suddenly enlarged lips, a caricature of the delicate child's mouth. His eyebrows, a characteristic family trait, darkened and became prominent. Although his eyes remained beautiful, myopia increased. Glasses were prescribed.

From then on, he suffered greatly in spirit. The anxieties of adolescence were complicated by cruel disappointment for this sensitive and intelligent young man.

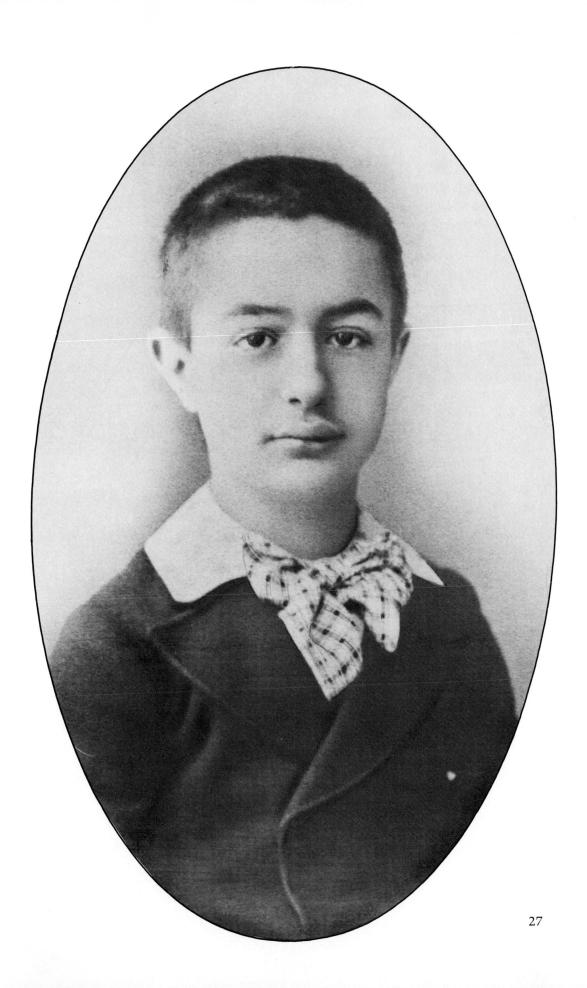

Intelligent and active, the neglected wife became more and more attached to her son. Handicapped by his double accident, Henri could pursue only irregularly a normal schooling. At a time when women were not yet blue stockings, she encouraged him particularly in Latin, and in English, a language used henceforth between mother and son.

But because of the demanding job of being the head of a family, the young countess seemed to lose a little of her femininity and to become somewhat hardened. However, this might have been only a mask or a shield. She conducted her business affairs like a man, watching carefully over her estate and property. Yet she was without bigotry, charitable to excess, deeply religious, and devoted to her practical duties and good works. She never ceased to support Henri financially, generously and even lavishly. She reluctantly decreased his allowance years later, but only to attempt to curb his disorderly existence. She would often repeat: "He is ruining his health and losing his soul." This son was, in turn, her consolation and her torment. Heroically, the Countess Alphonse accepted the unhappiness of her life. Her only smiles were for Henri's witty remarks and his success as a painter.

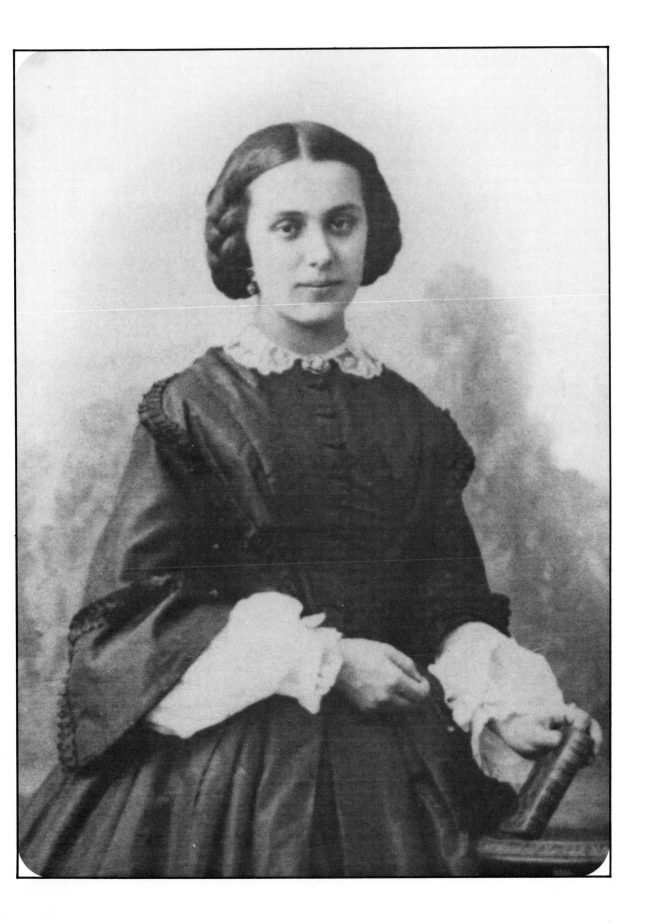

At this point, the Toulouse-Lautrec marriage was in visible disorder. There would be no question of divorce; rather, they struck a peculiar compromise where husband and wife became, once again, cousins. Courtesy and indifference characterized their relationship.

Poor Henri fell into the hands of doctors and women just at the age when he should have been escaping from the nursery. Although he had to abandon all sports, father and son still shared one great passion: drawing. It was a "family disease." Grandparents, uncles, the whole family, loved pencils, charcoal, and the brush. They all worked well with clay and wax. They all cherished the same subjects: horses, dogs, high-flying birds. In this area they communed, were entertained, and found inexhaustible joy. Drawing was such a habitual and normal activity in the house that nobody was surprised by it. It was found to be the best possible pastime for one who should always be "resting."

Henri's father was delighted that his son's tastes were so similar to his own. If there was no common ground for the married couple, at least the relationship between father and son began on a firm foundation. Count Alphonse introduced his son to René Princeteau, a friend from Bordeaux. Princeteau was a painter, and a deaf-mute who took an interest in Henri and encouraged his beginning efforts. Henri listened to him, asked for advice, and timidly showed his attempts to his father, but concluded: "Papa draws much better than I do."

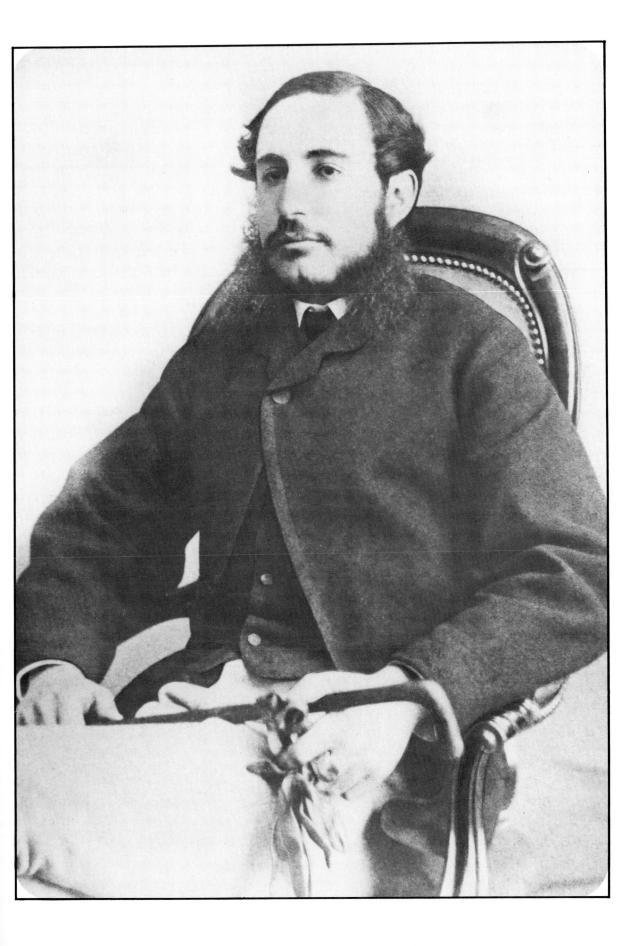

Settled with his parents in Paris for the entire winter, Toulouse-Lautrec slowly reached outside the family to find more of the freedom normal to a young man.

In this group—the first photograph in a studio—there is already a woman (probably Lily Grenier); his cousin Louis Pascal, right, the son of the perfect of Bordeaux, who would remain a faithful friend and companion and of whom he would paint a magnificent portrait; and a tender-eyed dog whom he pulls close.

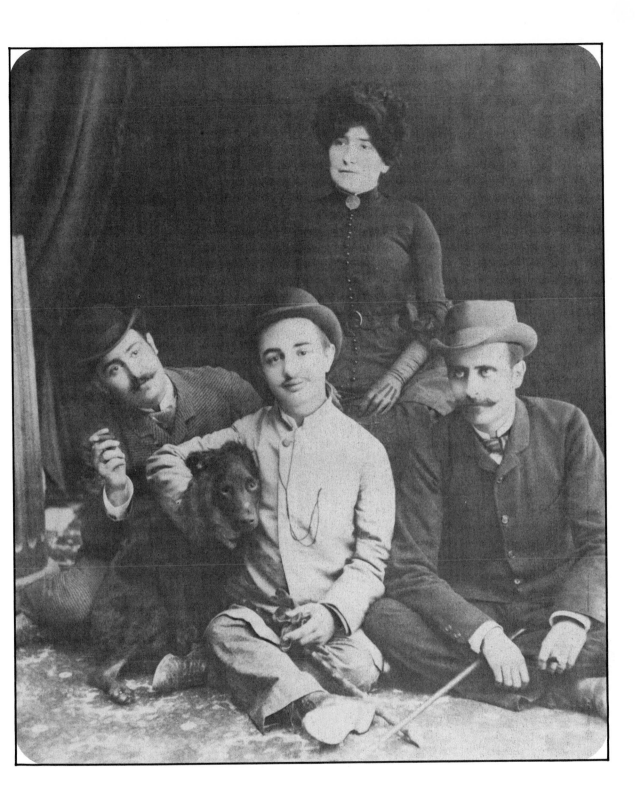

From the beginning, the master Bonnot fulminated against the "atrocious drawing" of this little man. For a year, Henri took it, enduring all the reproaches and harsh criticism without flinching. He believed that his first master's inability to understand was a necessary pain, similar to a boxing match in which he intended to emerge the victor. He would repeat: "All art or science must begin with the alphabet."

He then went to study with Cormon where he became friends with a foreigner, Vincent Van Gogh.

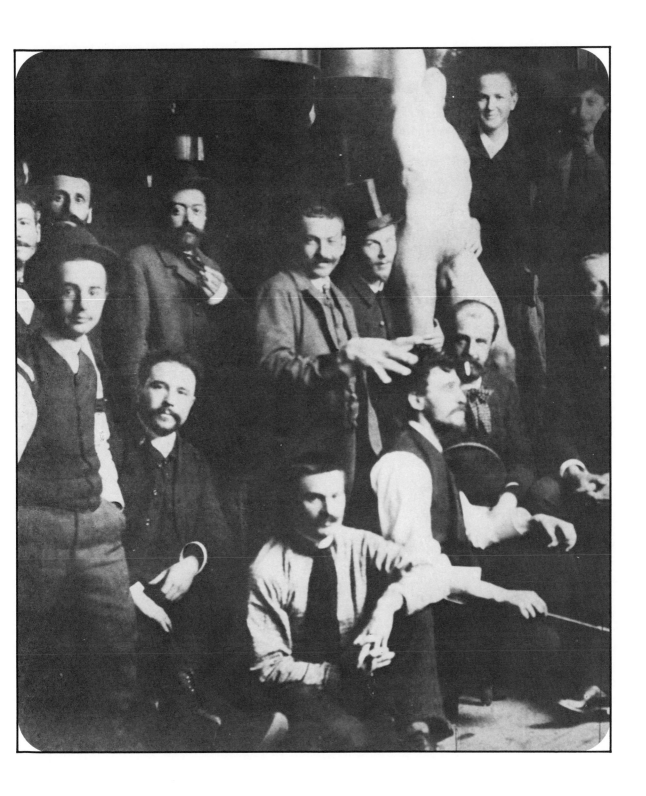

Clubs and cafes abound in Montmartre and "La Butte" became a center of night life.

After being led there himself, Toulouse-Lautrec soon led others and became the despotic and admired leader of those who made up his court: the Greniers; Louis Anquetin, the Giant; Henri Rachou from Toulouse.

These became true friends and, like Maurice Joyant, would remain faithful to him even beyond the grave.

Others, however, would profit from his generosity and unscrupulously take advantage of him.

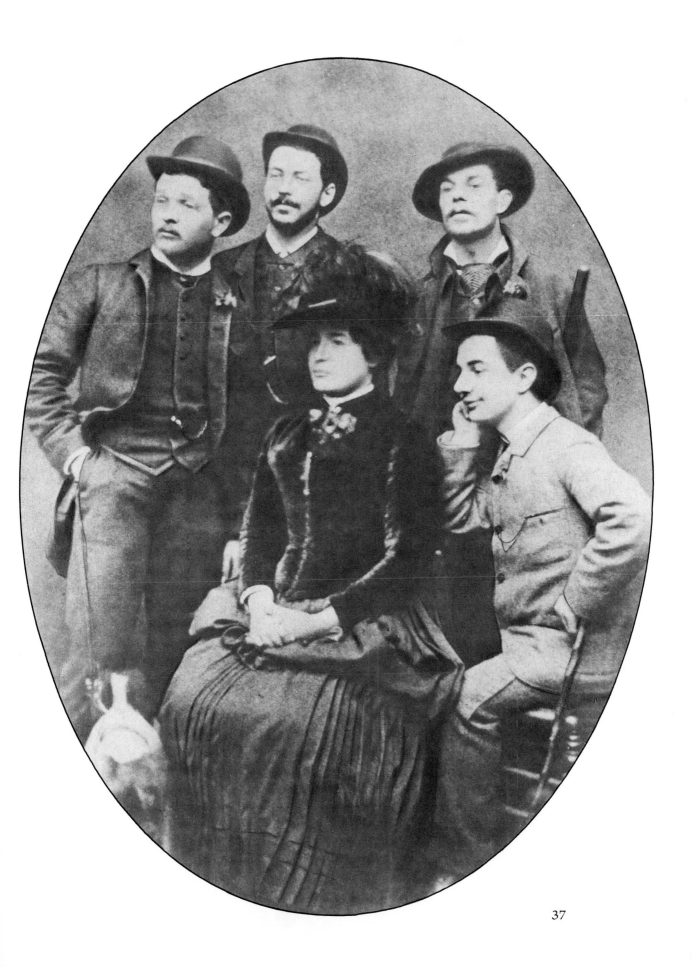

Even as a child, Toulouse-Lautrec
enjoyed masquerade. As an adult, that
inclination persisted, becoming almost a
necessity. Was his clowning a little
forced? Perhaps, but it was second
nature to him. And isn't everyone's life a
theater wherein he cries and laughs in
turn?

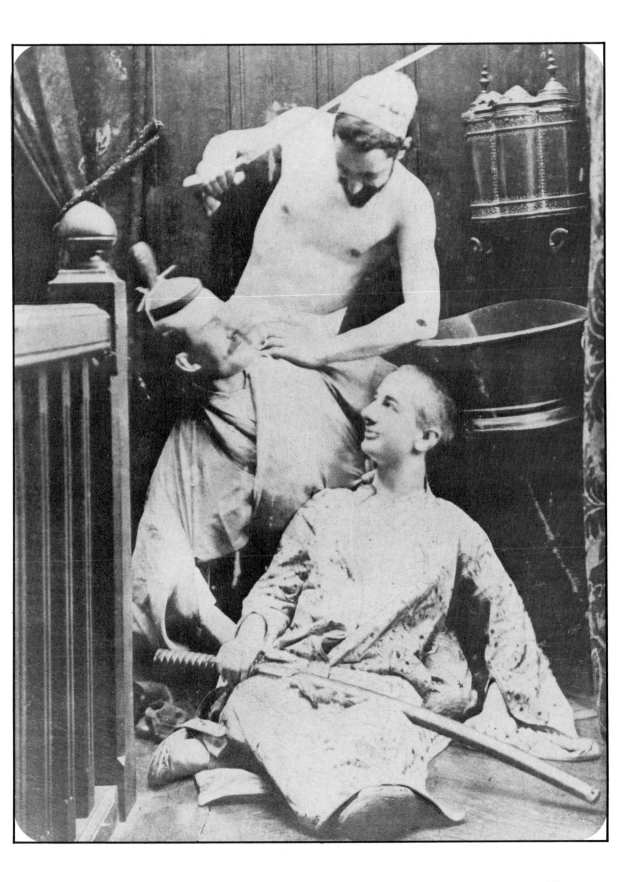

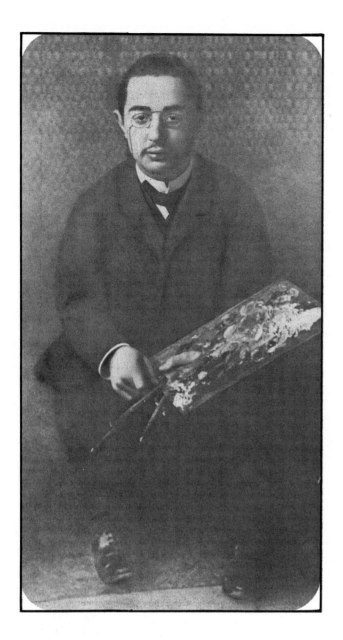

This official photo is a little conventional in order to give the discreet appearance of a serious painter who has his future well in hand. Henri poses with "Dame Palette," his comforter and best friend. But he is still a beginner who does not know what paths he will have to tread. We see him here shaven, but soon he would let his beard grow to hide his increasingly thickening features.

He was not attached to a particular character, but he made himself up in many disguises, only too happy, apparently, to hide his own face. And for hiding, any mask will do.

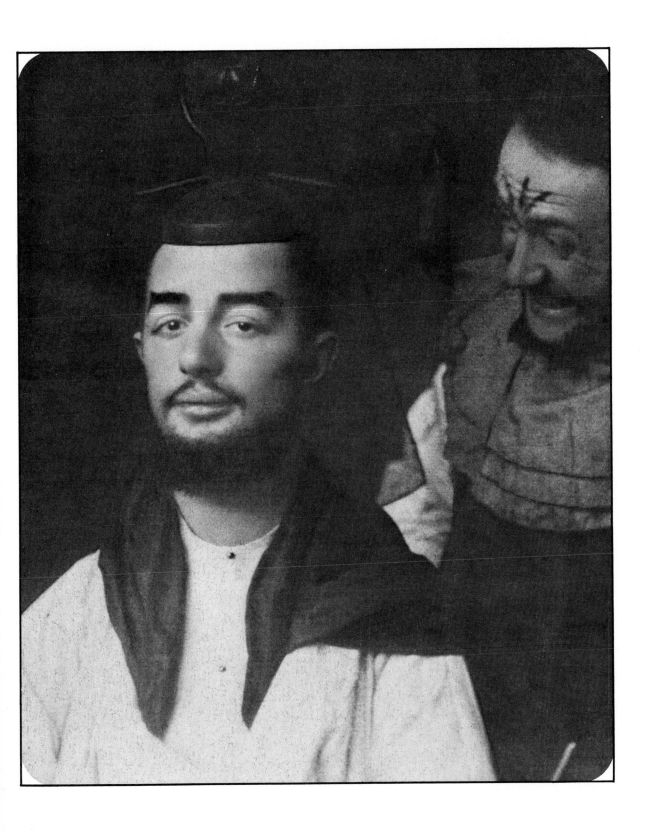

In this photograph with his friend, Louis Anquetin, Henri is dwarfed by the hunting horn and symbolically separated from the horse.

Loving and understanding horses from his earliest years and living in their company, he who could no longer ride, haunted the racing grounds and riding schools, guilty of the sin of envy.

Just meeting a rider was heart-breaking for him. "I shall always remain a thoroughbred harnessed to a gallows cart," he said. This offhand remark, on the surface so lighthearted, fooled no one. It contains a terrible bitterness.

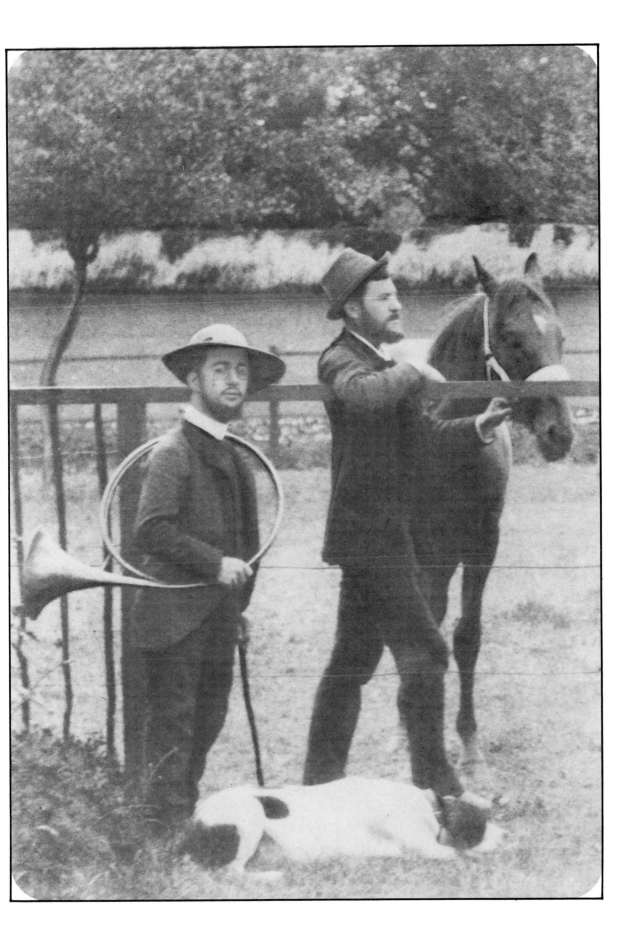

In the atelier of Fernand Cormon, his
second master, Henri raised the flag, not
of rebellion but of independence, and
affirmed his already very personal style.
He cared nothing about criticism and
accepted it with good grace, knowing
how to profit from it. He would
constantly repeat that one must master
one's trade, that success comes only after
difficult battles, that life is a race and
only the best may win.

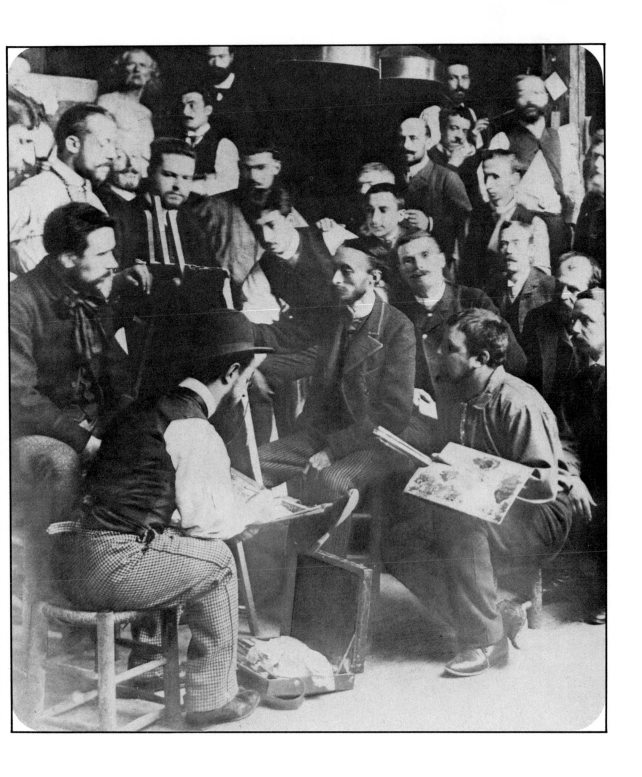

Toulouse-Lautrec discovered the
Mirliton, a night-club where he became
infatuated with the owner, Aristide
Bruant. The admiration was mutual. The
artist saw a model who would bring him
good luck. Bruant sensed, whether
through cunning or instinct, that this
newly arrived young painter would be a
colorful attraction for his cabaret.

From then on Lautrec was caught in the
grip of Montmartre. He would never
escape it. He became the explorer of
Paris by night, the "enchanted seer."

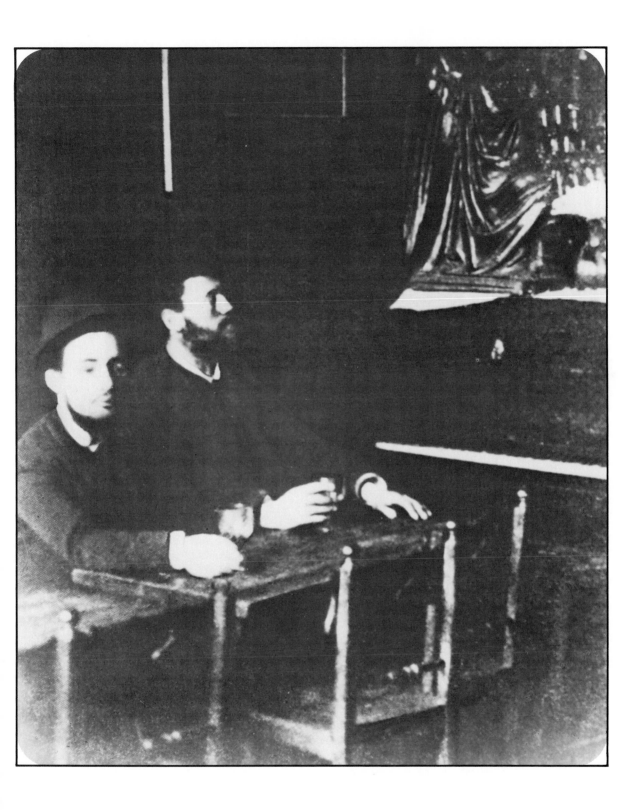

In a bower with La Goulue (The Glutton), a favorite model and night-spot entertainer, Henri and his friends look like a Renoir composition. They are drinking warm wine, a specialty of the Moulin de la Galette (Cookie Windmill).

Every night there were fetes at the Elysée-Montmartre, the Chat Noir (Black Cat), and the Fernando Circus, where our painter delighted in the thousands of subjects offered to him by the grand parade.

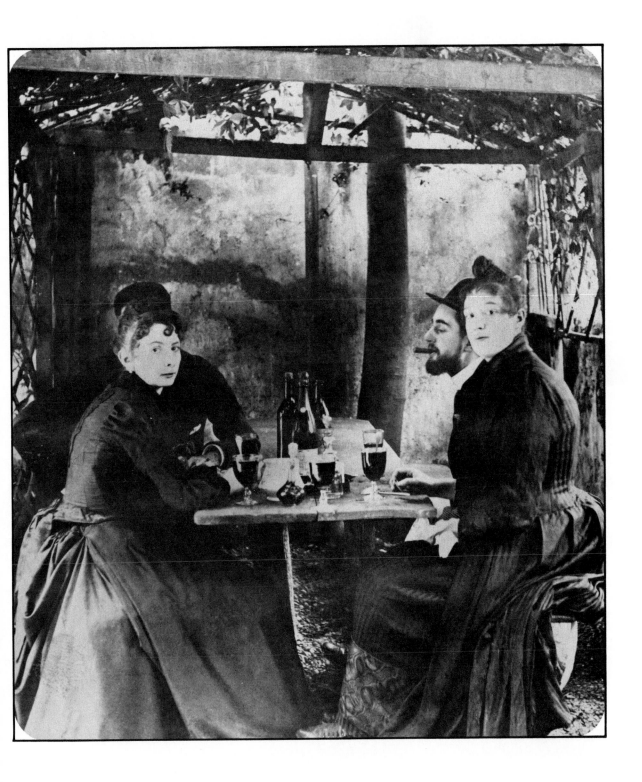

Despite his feverish night life, Lautrec worked hard, first in Henri Rachou's studio, then at the studio of a painter from Toulouse, François Gauzi, at number 7, rue Tourlaque. Later, in 1887, he set up his own simple studio on rue Caulaincourt.

It was a veritable curiosity shop. Lautrec, like his father, searched out and collected the most incongruous objects. Absinthe was always on the table. His friends said: "He would swallow turpentine from his painter's box rather than go without drinking."

He is seen here with Lucien Métivet, another poster artist.

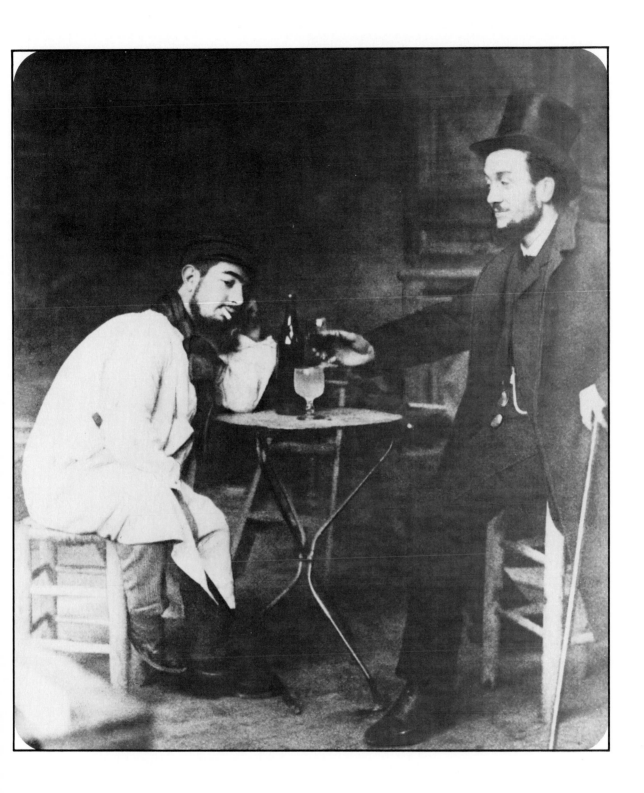

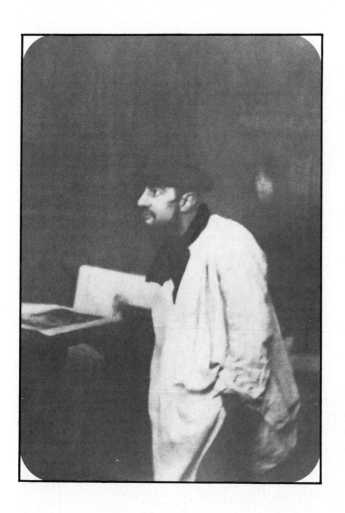

Gauzi, the Toulousian, recalls, "Lautrec's atelier attracted the attention of two peculiarities which did not bother the painter at all: an inextricable disorder and an abundance of dust. It was furnished with an old oak cabinet, a large studio ladder three meters high, and an enormous portable easel.

"For my second portrait, Lautrec had painted me full-length, as tall as a poplar, with a top hat on my head and hands in my pocket. This time, his eye was caught by a green overcoat, and I posed with it on."

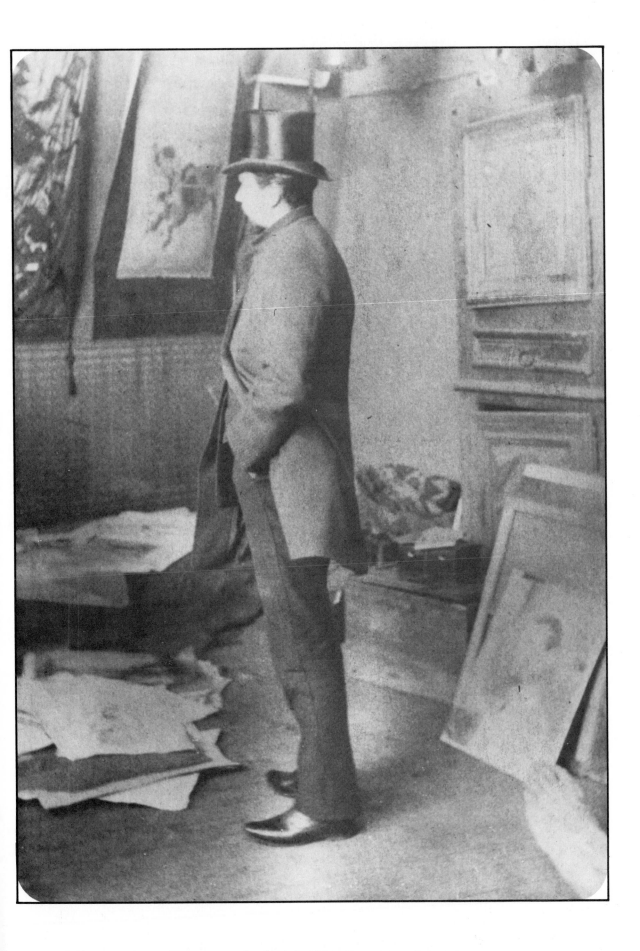

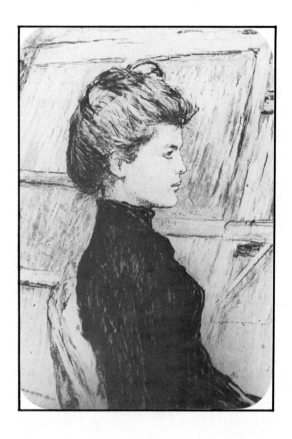

One day in 1888, Lautrec remarked to
Gauzi: "Do you remember little Hélène
Vary, the girl who posed for me two
years ago? She has become very
beautiful, extremely beautiful, exquisite.
I am doing her portrait. Come with your
camera; I'd like to have her picture. Her
grecian profile is incomparable."

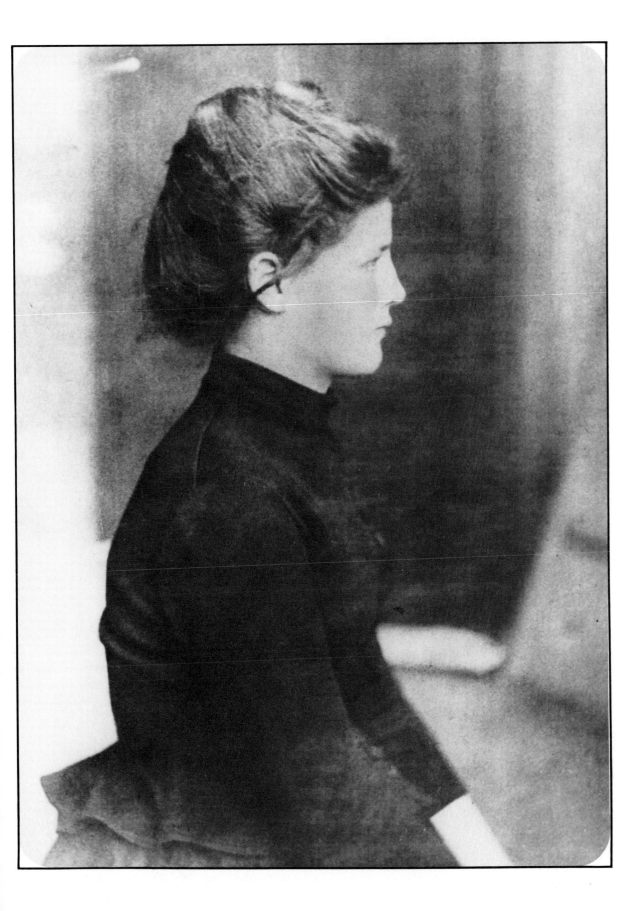

René Grenier, his wife Lili, and Toulouse-Lautrec masquerading as a choir boy, are photographed in 1889 at a ball. After Lautrec's death, the rumor ran through Languedoc in the south of France that his nostalgic ghost sometimes haunted the Bailli Tower of the Château de Boussagues in Hérault where Countess Alphonse supported a small community of nuns. Sister Justine Justin, (who did not know Lautrec), reported the spectre's appearance precisely, including his choir boy costume. There is a connection between this and one of Henri's comments: "I can sin to my heart's content since my mother supports an old tower full of nuns whose only duty is to pray for me and my salvation."

Who can say that this is only dreams and nonsense, and that there are no lost souls doomed to roam the earth?

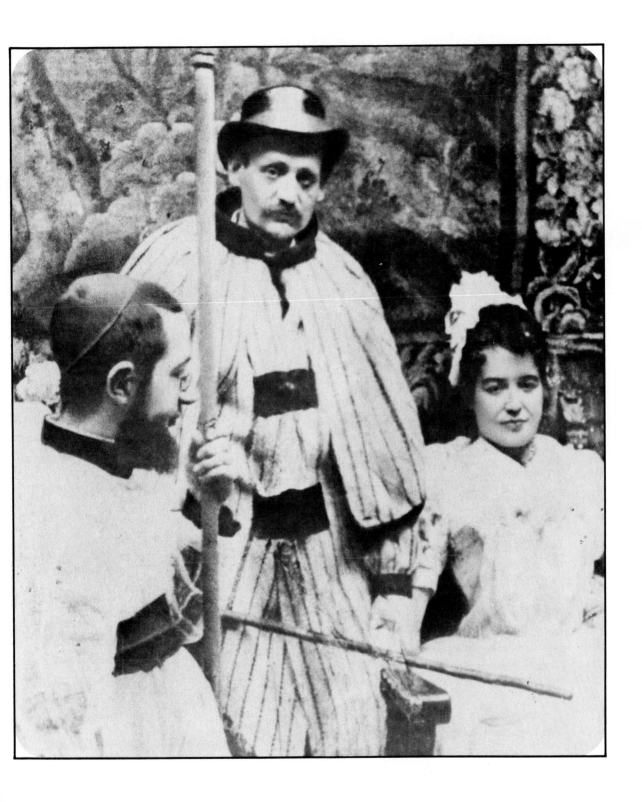

Escaping from his milieu, Toulouse-Lautrec went off on his own to discover a strange and fascinating world. He placed himself in the front lines of the battle between the young Impressionists and their traditional conservative masters, and against an unrestrained press. We cannot know what emotional struggles he also had with himself, considering his inherited characteristics and his education.

On 24 June 1887, Lautrec was singled out and castigated by *Le Messager de Toulouse* (the Toulouse Messenger): "Before the painting of Monsieur Tréclau, a transparent pseudonym, visitors shrank with horror. Such work must not be tolerated! Purple hair, lemon features which look like mashed potatoes! Monsieur Tréclau is enlisted in the company of which M. Besnard is the captain. We advise him to desert it."

The family's reaction was to rally. The dowager Countess de Toulouse-Lautrec, Henri's grandmother, was grieved and mortified. She wrote: "Won't this ignominious article discourage our little one? It would be unfortunate, after so many years and so much money spent, to end up in such failure. . . . Won't he at least defend himself with an angry response?"

Far from letting himself be discouraged, Lautrec coolly persisted: "What glory if. . . . But let's not count our chickens before. . . ." And, in a letter to his Uncle Charles: "You at least will not abandon painting. . . . Thank you for admiring my own. . . . Let's hang on!"

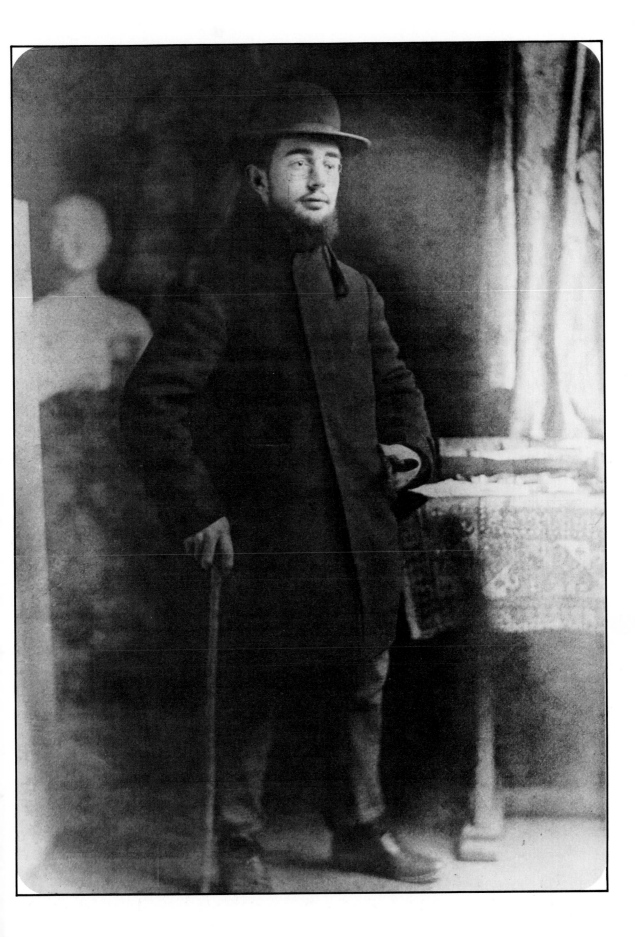

The pleasure of boating, the magic of the water, the salt air, the smell of pines—all the things of the sea charmed Toulouse-Lautrec, as this photograph taken on vacation in the Arcachon Basin shows. Rowing and swimming were the only two sports he was allowed to enjoy, and at the helm of his little yacht or in the midst or a hearty swim he became again a normal young man.

As a child still strong and in good health, Henri often vacationed in the stony, sun-drenched hills of Languedoc at Arcachon with his mother and cousins. Perhaps it was to relive his childhood memories that, as an adult, he chose whenever possible to stay in Taussat by the bay in the midst of the forest. But certainly it was, too, that his mother purchased the castle and estate of Malromé near Langon on 20 May 1889. It was a spacious and beautiful house restored by Viollet-le-Duc.

One of Lautrec's uncles wrote: "Will Henri fill Malromé with a great posterity? He thinks very seriously of getting married."

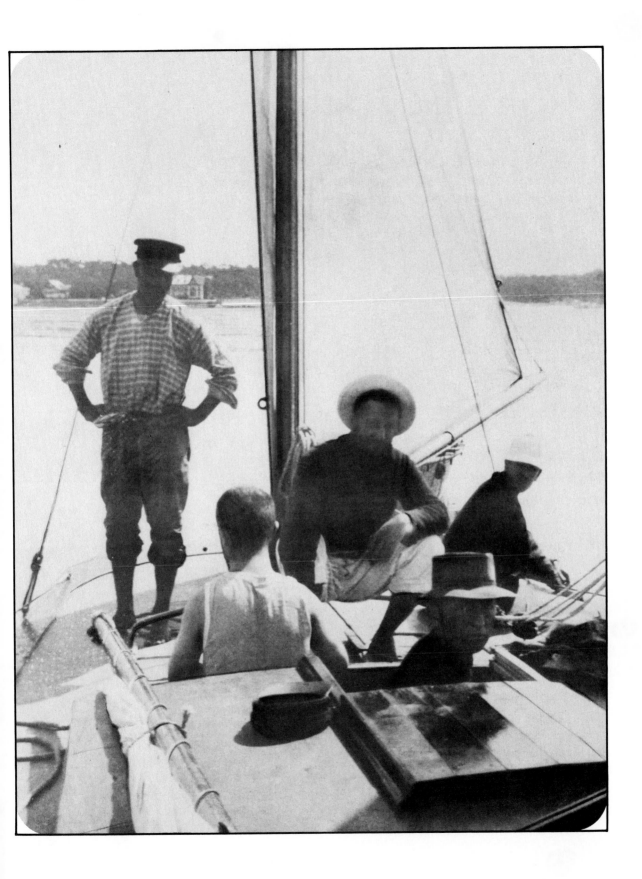

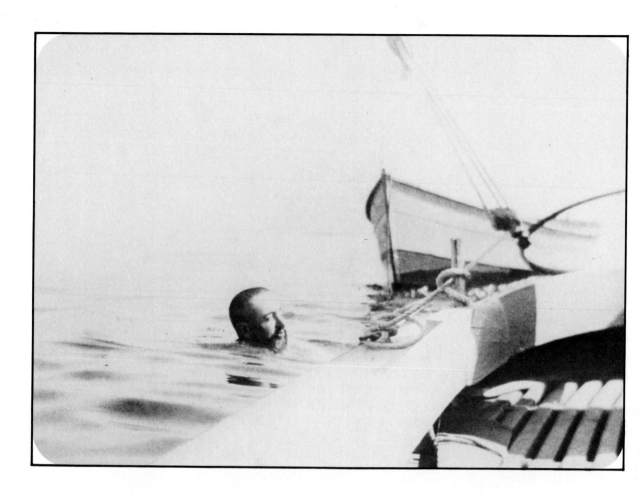

Once in the water, he swam well and fast—"like a duck," he would say, making fun of himself.

He was exultant. He always had a good appetite, possessed as he was of the strong "Lautrec stomach." On the very bridge of the boat, exhilarated, he concocted elaborate bouillabaisses, refining his recipes with priestly gravity. His cousins called him "Henri the cook" before he became, for all eternity, Henri the painter.

It was when he emerged from the water with his suit draped awkwardly over his oddly shaped body that he shocked onlookers, reported a friend, Thadée Natanson. Whenever he could, Lautrec did not hesitate to sunbathe in the nude.

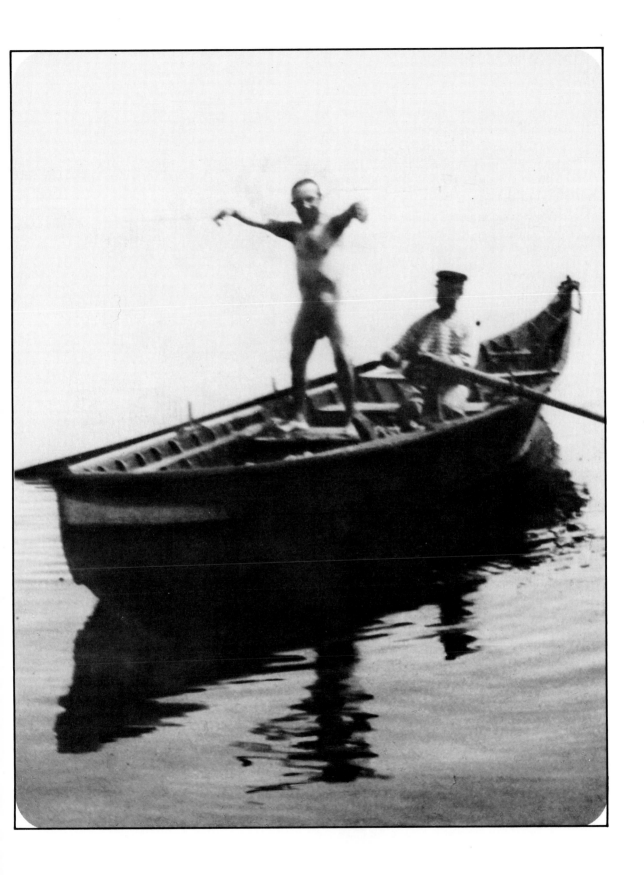

After swimming long and gloriously, he would give himself over to the care of his bath-attendant who gave him energetic massages and helped him dress.

After his pampered childhood, Lautrec retained a great pleasure in comfort all his life.

Swimming must have partially compensated Lautrec for the loss of his beloved sport of riding. Those who saw him swim in Arcachon, Taussat-les-Bains, or Villeneuve-sur-Yonne, knew the strength concentrated in the muscles of his diminutive body.

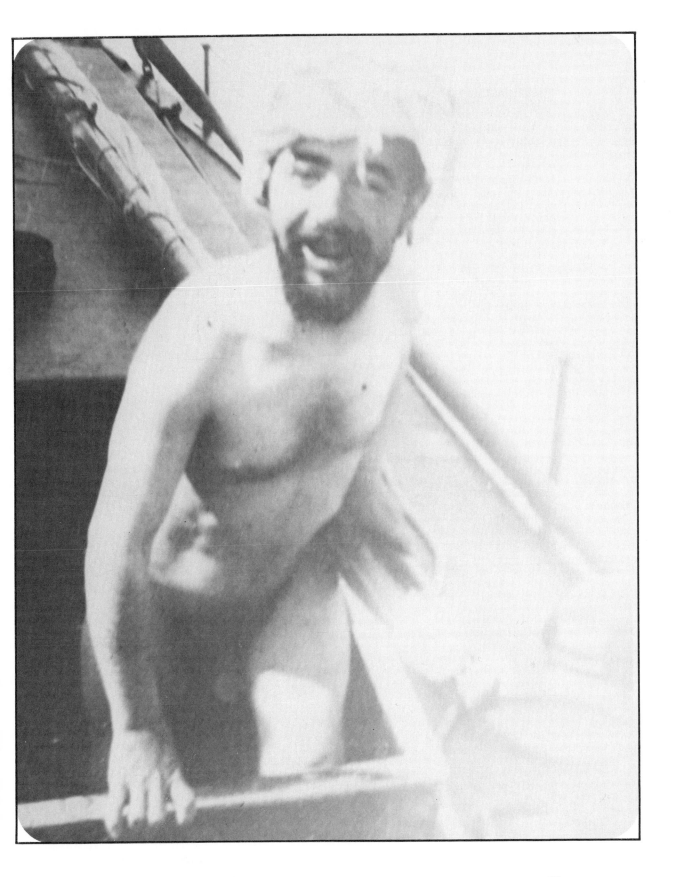

After his last swim before returning to
Paris, he warmed his poor bones under
the life-giving sun on the deck of the
*Cocorico (Cockadoodledoo)*.

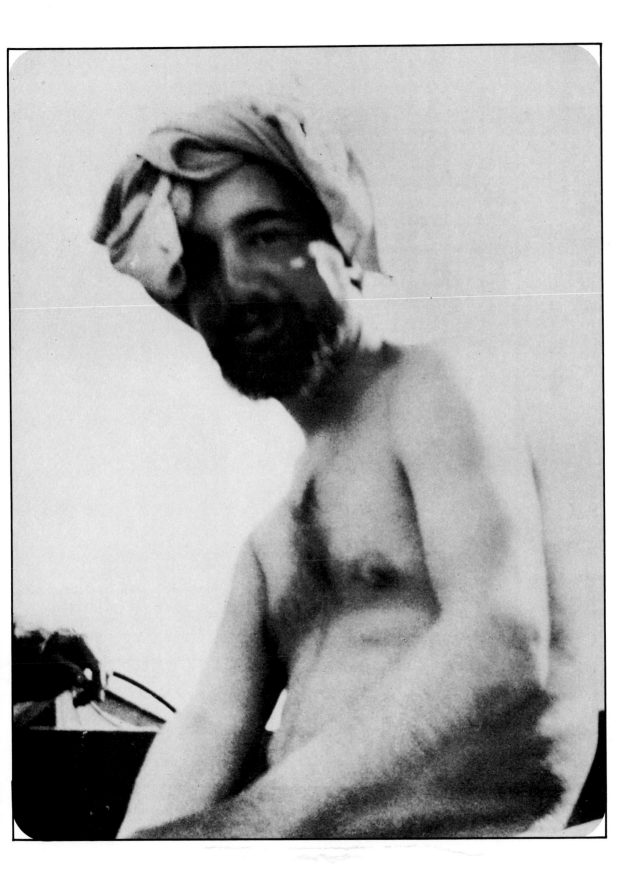

This peaceful garden of Père Forest, a retired photographer, could be in Albi or Narbonne just as well as in Paris: white chestnut trees; hyacinths wet with the spring showers; a little marble god hiding in a grove of lilac bushes; a tranquil path where Lautrec hides away to work as comfortably in Paris as in the peaceful grounds of his ancestral estate.

He set up his easel in this tranquil corner where no one would disturb him, but in the shed where the gardener kept his tools, he also set up a bar!

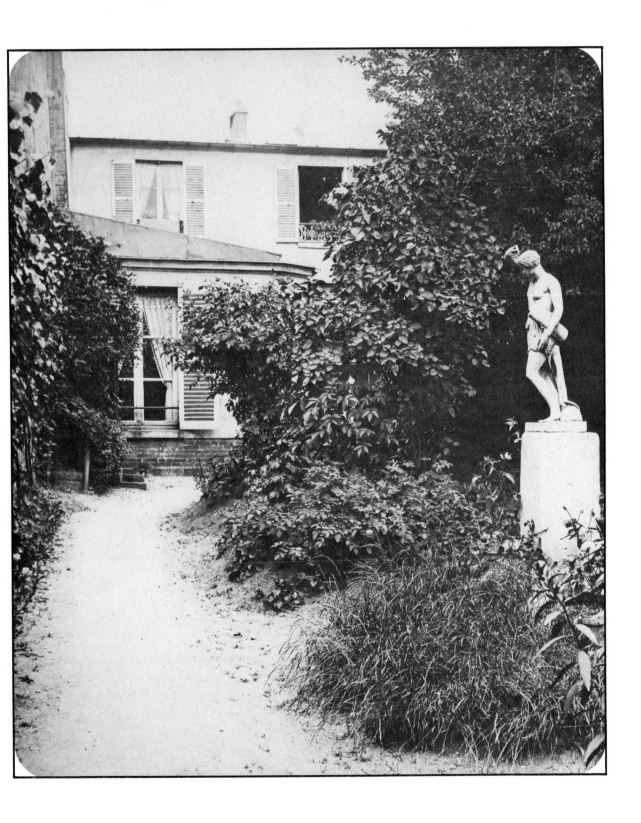

In a practical light suit with a straw hat pulled down as in the colonies against the torpor of the burning summer of 1890, Henri works euphorically at the portrait of Berthe the deaf girl.

Except for his disastrous habit of drinking too much, this was a relatively happy period of his life. He could feel his talent swelling like a salutary tide.

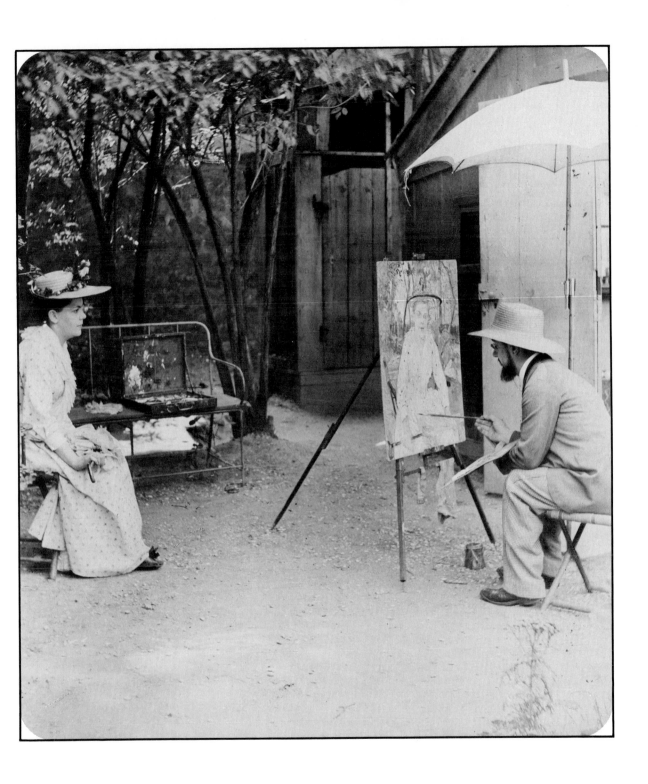

These two photographs were taken on the same plate. Lautrec was happy to pose, and the superimposed shots delighted him as did anything smacking of a good joke.

He adored mystifying people, and his true nature would probably have been to be a carefree fellow. He was not afraid to make fun of himself. He had no illusions about his physical appearance and would cheerfully compare himself to a chestnut salesman from Auvergne.

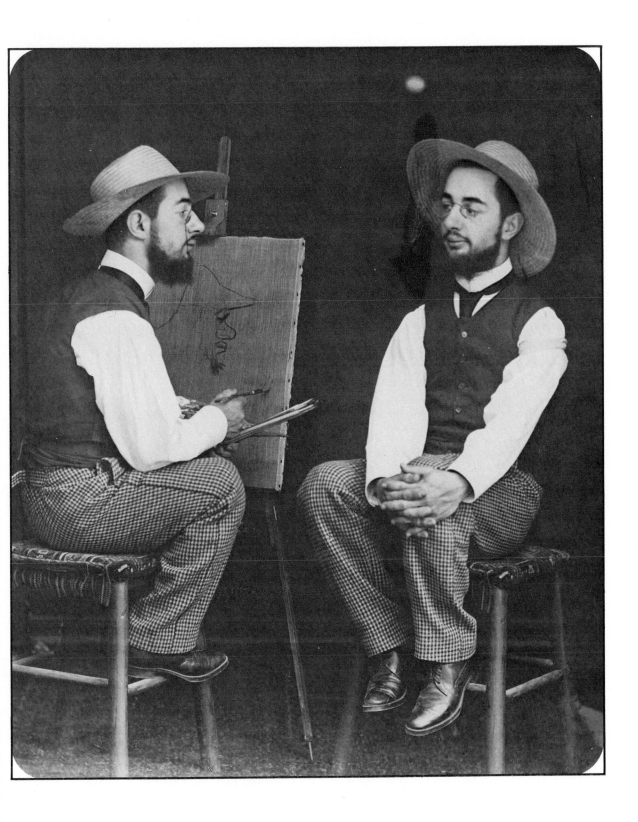

Against the sky of Montmartre at the entrance of Place Blanche, a blood-red windmill, the famous Moulin Rouge, turned its rustic wings.

Manager Charles Zidler collected his profits nightly from his famous quadrille whose stars will remain immortal: La Goulue, Jane Avril, Rayon d'Or (Golden Ray). Valentin le Désossé (the boneless Jacques Renardin) escorted this pléiade. Yvette Guibert, whose trademark was her long black gloves, sang her ballades here.

On opening night, 5 October 1889, Henri de Toulouse-Lautrec discovered what would become his favorite night-spot.

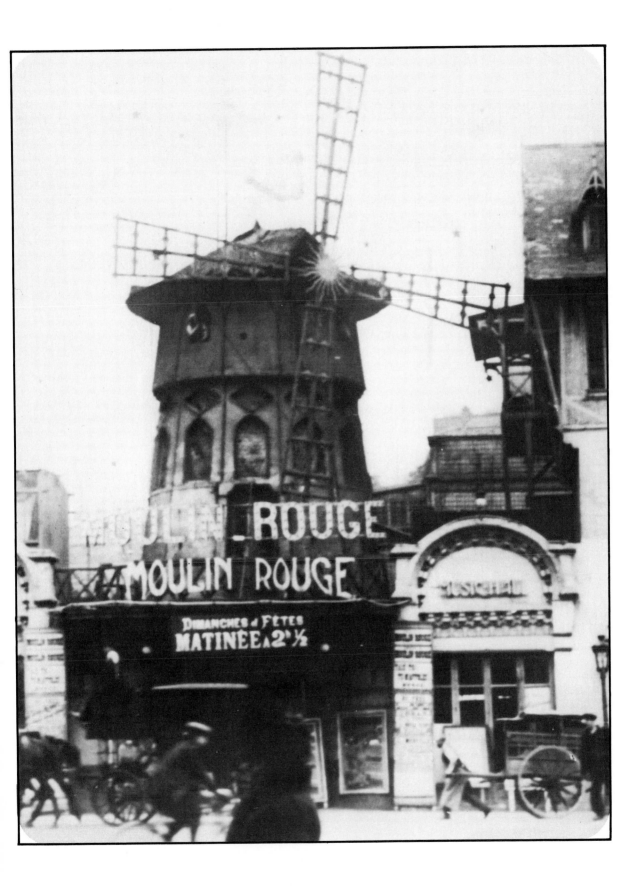

La Môme Fromage (Cheese Poppet),
poses in Henri's studio.

The atmosphere is disorderly. The
woman, nude except for her black
stockings, holds Lautrec's palette and
daubs signatures on the wall, already
decorated with his sketches. She is
surrounded by a jumble of paintbrushes,
boxes of paint, and jars of varnish.

This haphazard and rudimentary decor
was the statement of a young and
carefree painter. Later Henri would
establish a refined and elegant house for
which nothing would be too beautiful.

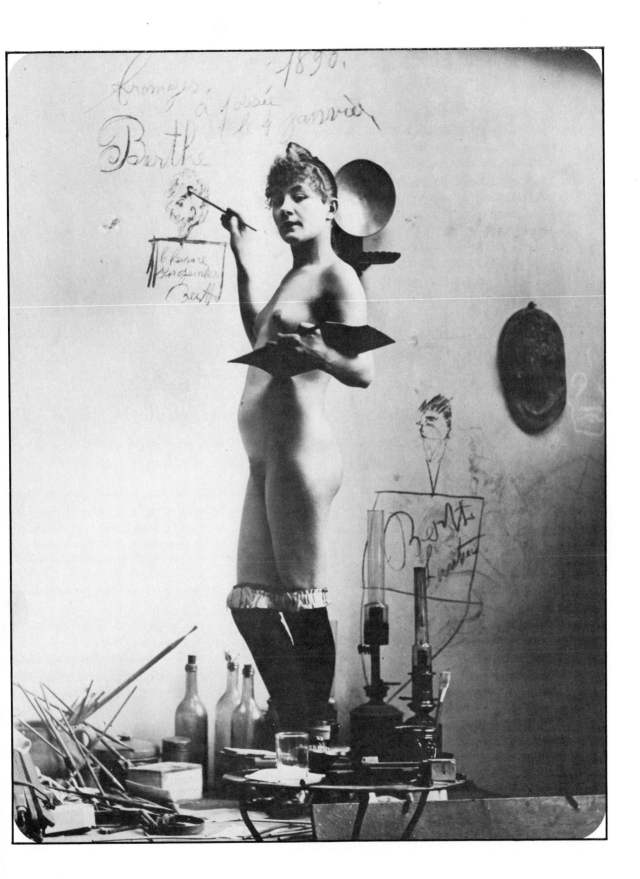

A star of the first magnitude arose in
Montmartre, red-haired, demanding, and
whimsical—La Goulue, whose voracious
approach to life led to her nickname,
"The Glutton." She had a little aquiline
nose like a bird of prey, provocative eyes,
a certain arrogance when she espied an
admirer over her shoulder, and a
rouguish way of swaying her hips, of
kicking up her legs, of tossing up her
petticoats.

Henri was much taken by the splits with
which she climaxed her act, and by the
extraordinary partner she had chosen for
herself, Valentin le Désossé, seemingly
an invertebrate skeleton. She ground her
teeth when Lautrec attempted the least
little sketch and submitted only when
Zidler ordered her to become Lautrec's
model.

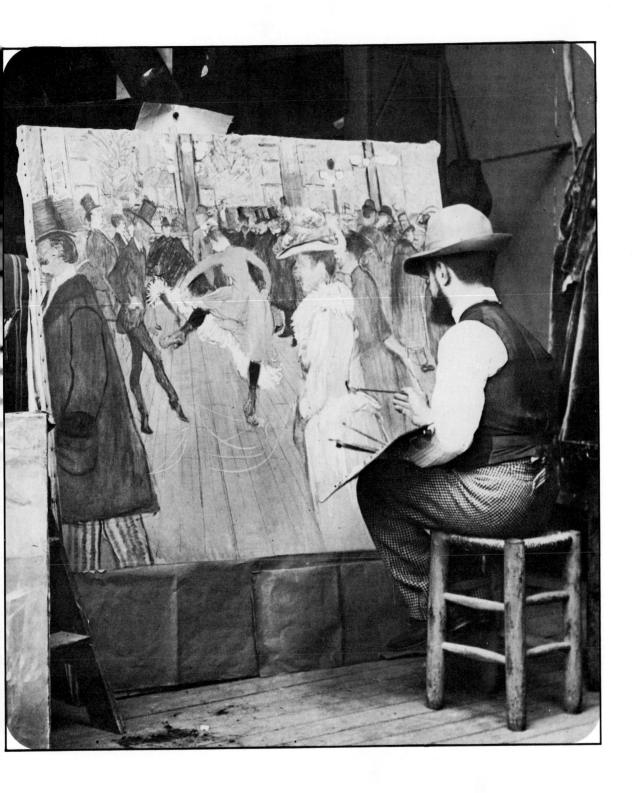

Heedless of ridicule, since everyone loses
himself in disguise, when any one equals
any other, Henri donned the typical 1890
costume that one of his models might
wear: the long ostrich feathers called
weepers on his hat, a boa around his
neck, and a coat with multiple capes.

There is mystery in his halfclosed eyes.
Is Lautrec mocking himself or others?

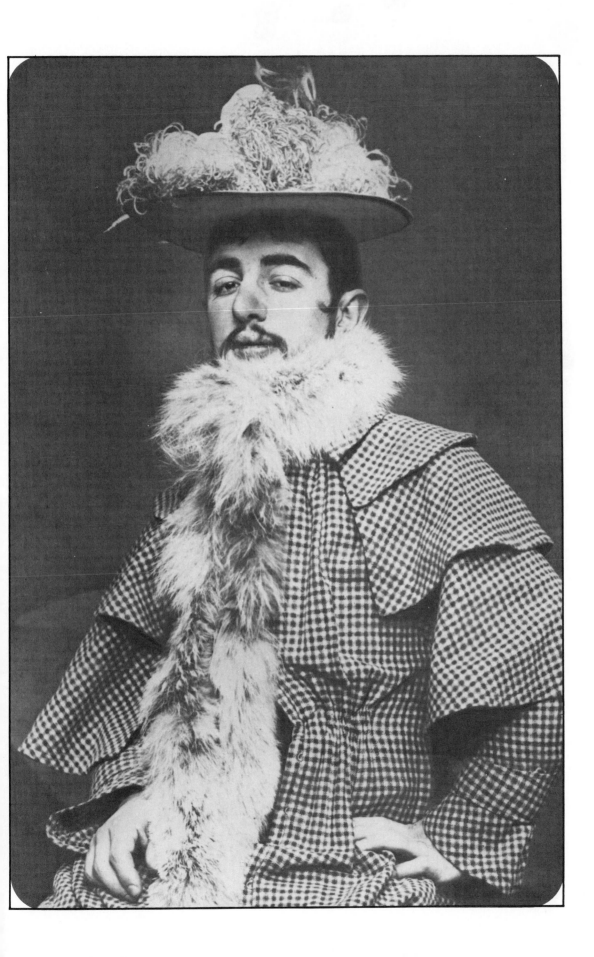

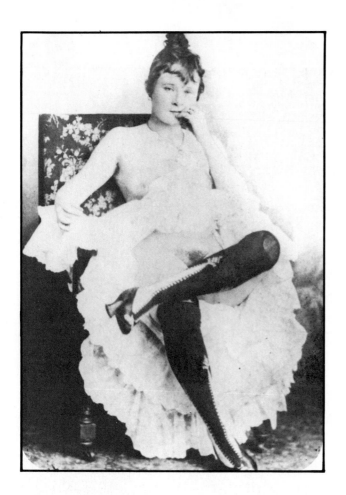

La Goulue (Louise Weber), star at the Moulin Rouge, was a native of Alsace, young, pretty, and rose-fresh.

After having danced at the Moulin de la Galétte, then at the Jardin de Paris, she joined the entertainers at the Moulin Rouge in late 1890 at the age of twenty, where she would be the main attraction for five years.

Her perverse charm seduced young Lautrec, and she was his favorite model for many years.

The manager of the Moulin Rouge, Zidler, was immediately drawn to the young painter. He appreciated Lautrec's kindness to people he liked, his independence from people he didn't like, his refined courtesy—the legacy of his education—and his stinging ferocity towards those who forgot who he was. Zidler also appreciated talent. He asked Henri for the poster that would mark the beginning of his fame.

The poster Zidler points to, one by an artist named Jules Chéret, would soon be forgotten.

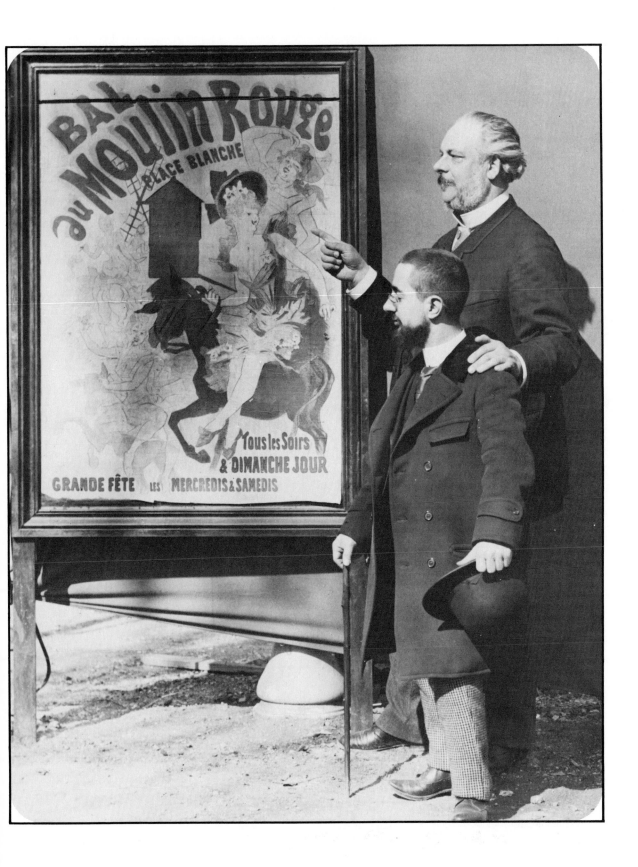

Eglantine Demay, manager of the dance troupe, commissioned a poster for England where the quadrille from the Moulin Rouge would perform. Jane Avril, a member of the company, is the can-can dancer on the left.

Ironically, when the troupe performed in January 1896, the British claimed to be disappointed because the dancers were "too respectable."

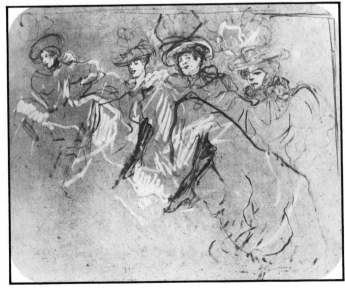

One morning, Paris awoke covered with posters signed by Toulouse-Lautrec. They roused immediate reaction—complaints, surprise, criticism, or praise. What a wonderful stimulus for Lautrec as he took the pulse of the capital. He felt wings sprouting and rejoiced: "I will paint to my heart's content." He had staked out his domain: the world of fashion, the most sparkling entertainment places, the essence of Parisian life would be his model.

It was a great beginning.

How evocative of the Belle Epoque is the slim figure of La Goulue, queen of the can-can; and the top-hatted profile of Valentin le Désossé, with his long chin and black-gloved hand. In the foreground, Lautrec seems sunk in reverie before these two models he has immortalized.

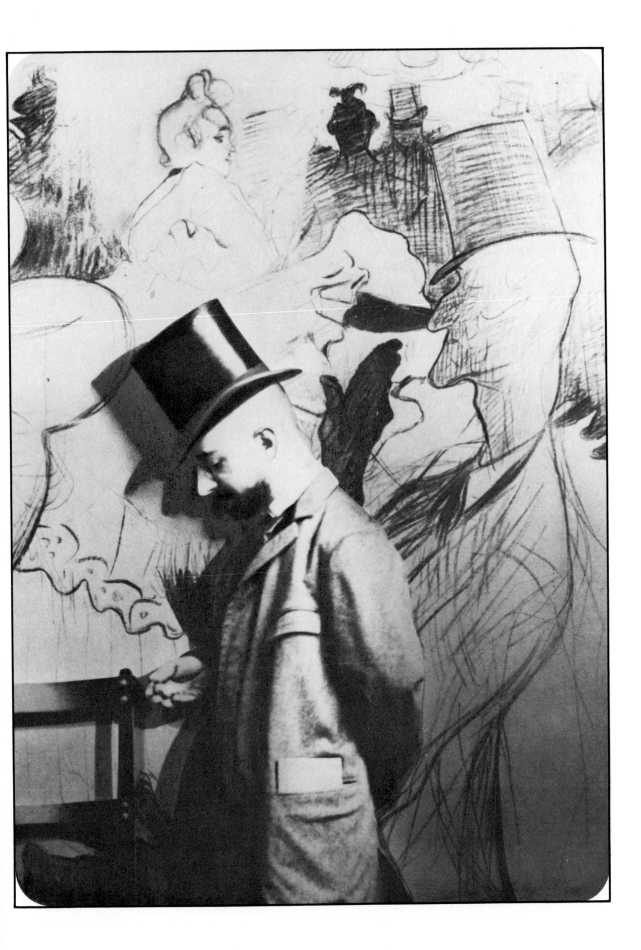

With a friend, Lautrec strolls down the boulevard that was, in some sense, his home. Pencil in hand, filling his inseparable drawing pad with a line, a curve, a sharp-edged shadow, he sketched the portrait of the Paris of the Belle Epoque.

To the last blaze of the frenzied orchestra, the red windmill turned its wings of fire. The bows stopped. Hastily the tables and chairs were stacked. New sawdust was spread on the dance floor. The cold smell of tobacco and absinthe hung over the gaslights. Everyone left but Lautrec, who would wander from bar to bar until daybreak.

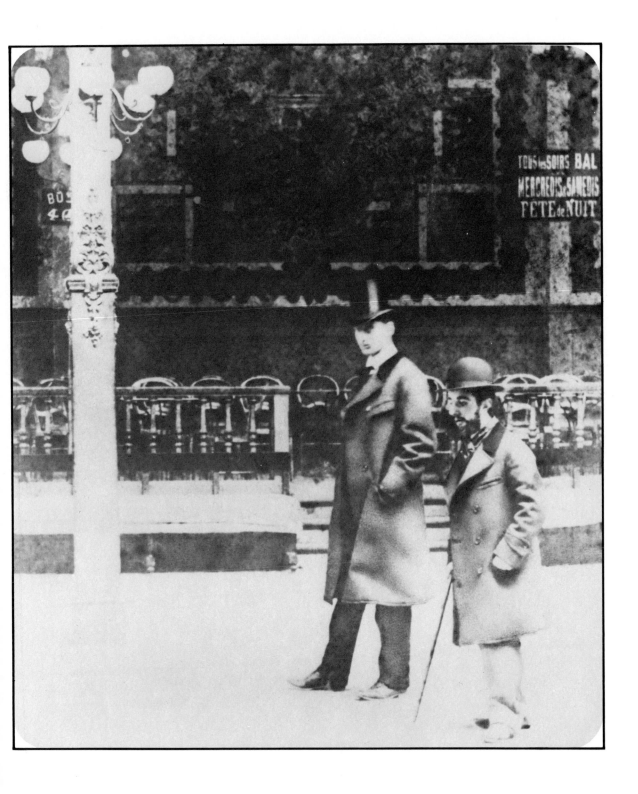

TOUS les SOIRS BAL
MERCREDIS & SAMEDIS
FÊTE de NUIT

89

This portrait of himself with his little white hat and starched shirt would hang in a privileged place, the parlor of his mother's house.

Each day, Lautrec's style emerged in strength and clarity. So did his willful and domineering personality. A strange little man who walked up rue Caulaincourt past the pimps and the women of Tabarin, he announced his slogan: "I seek the true, not the ideal."

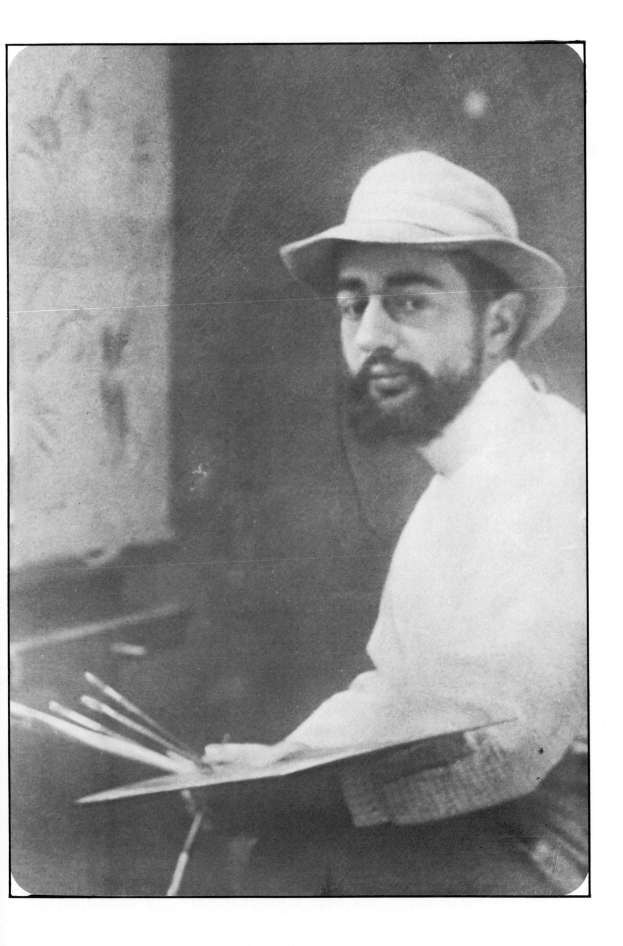

How many women paraded before the relentless eye of Lautrec, a born observer seeking Beauty among the beauties and giving it his full enthusiasm when he found it. Cléo de Mérode, for instance, became his standard of exquisite beauty against which all other feminine faces became coarse.

But his refined aristocratic judgment did not fear extremes. He also took inspiration from any drunk girl, from any monster "with a large bottom and big breasts." He was moved by Beauty; his spirits rose mercilessly only against ugliness.

In all that it entailed, from the hideous to the sublime, Parisian life would always be an enticing forest for the little huntsman.

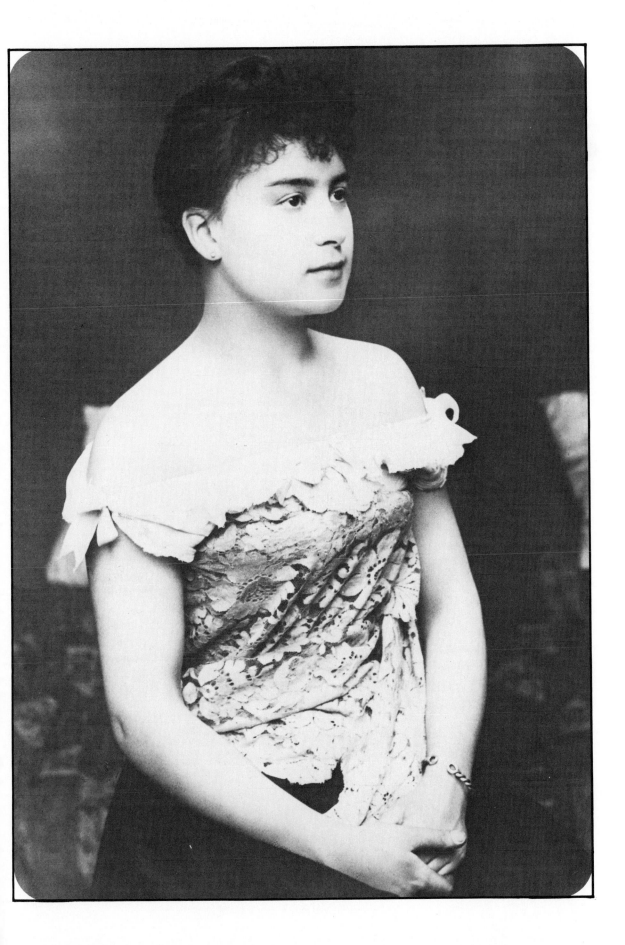

Here Lautrec takes the pulse of physician Maurice Guibert. His cousin Doctor Gabriel Tapié de Céleyran, an intern, looks on in amusement.

Several times a week, having more and more right of entry, he would work in surgery rooms in big hospitals. He sat on the first row drawing furiously. At home, from these sketches and his incredible memory, he would recreate the greenish color of the patient and the high comedy of the great "Knife" (the surgeon), operating with dignity in tie and tails with only a towel tied around his neck for sanitary protection.

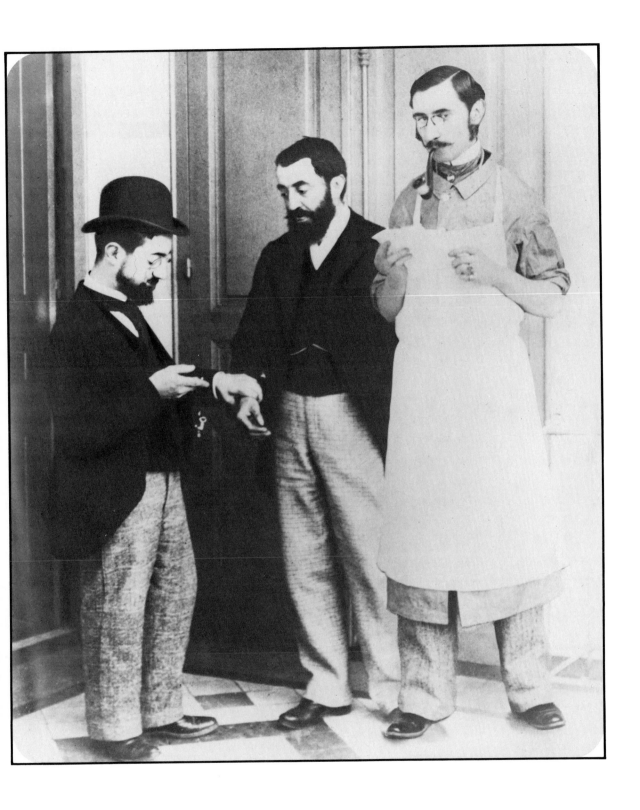

Lautrec did not want his paintings to be only a pastime. He wanted them to sell, and so he visited the Marchand.

Thomas, on Boulevard Malesherbes, to his joy, bought his first painting.

Some time later, commissioned to do a painting, he had to use a model he had not chosen. She thought he hadn't made her face pretty enough. He'd been willing but, as he put it, had "made her as pretty as I could."

Lautrec loved women as he loved good wine. Always they represented attraction and mystery for him. Dragged along by his new life and by his comrades in revelry, he would soon no longer be satisfied with the nude as a model. And from balls to night clubs, he would soon descend to houses of ill repute, not only professionally but personally.

He paid well, was there received like a king, and even accorded a kind of deference. However, we would not think that, from the point of view of romance, he could have found there sufficient romantic balm for his solitary heart. But his study of movement in all its forms there found a territory he had not yet explored. He would descend into it, the very antipodes of his own world.

In front of the *Dames au Salon*, Henri smiles broadly and does not hide his satisfaction. Face alight with mischief, he seems to be mocking all those whom this great painting will later shock. Perhaps he realizes that these sad, almost chaste, faces are a masterpiece.

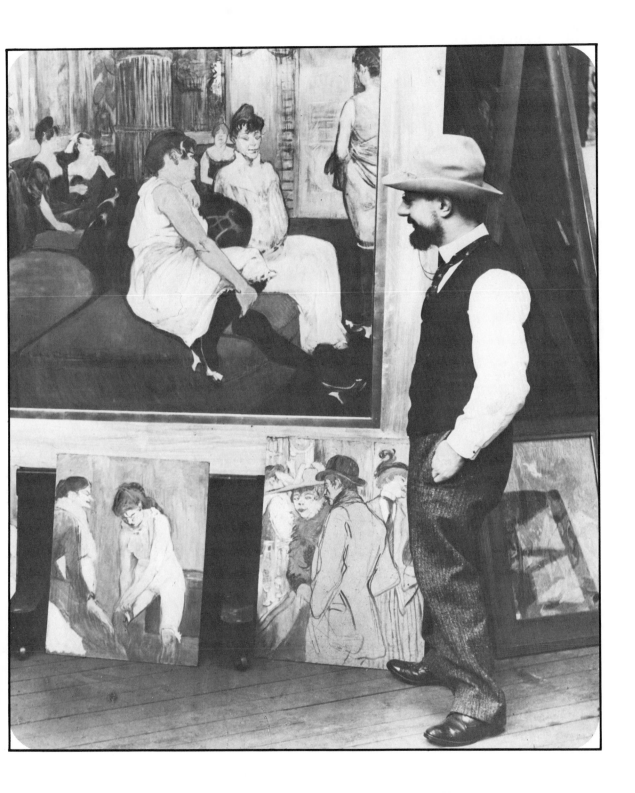

Exhausted, all worn out, Toulouse-Lautrec would fall asleep anywhere and everywhere. Too much alcohol, too many women. No one had any illusions about his future. Yet he worked assiduously. How could he sustain such a dissolute, disorderly pace, changing day into night and night into day? How could he draw with such assurance, his lines still sure and bold?

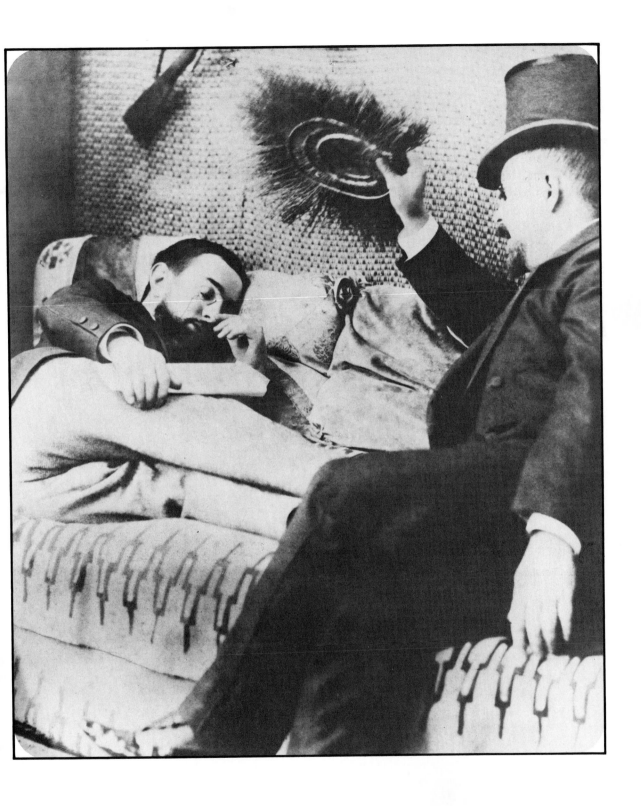

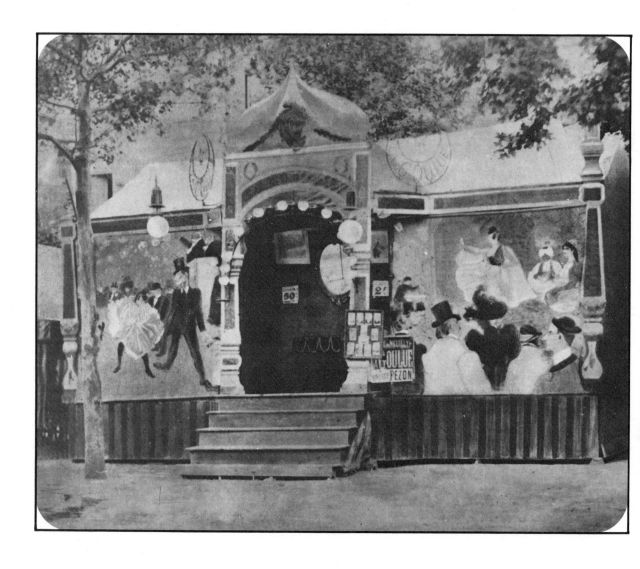

La Goulue abandoned the quadrille and the can-can, of which she was the queen. Previously so hostile towards the drawings that Lautrec wanted to make of her, she now implored him to decorate her modest booth at Trône Fair. Once again it would be a success which delighted all of Paris. For Lautrec, it was a chance to attack the problem of decorations on a grand scale, a challenge he had always wanted.

In 1904, academician Léon Bonnat opposed hanging a Lautrec painting in Paris's Musee d'Art Moderne. Today the panels of La Goulue's booth are on exhibit at the museum of the Impressionists.

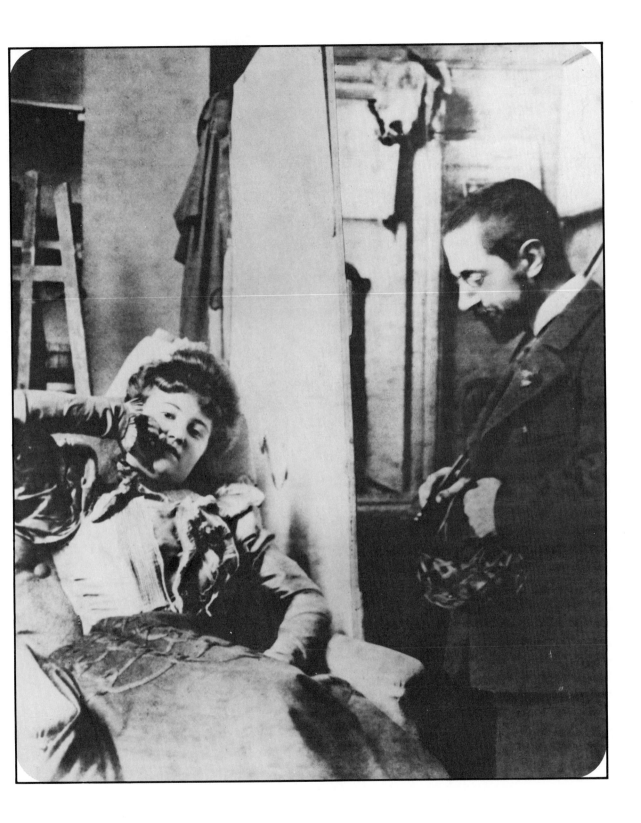

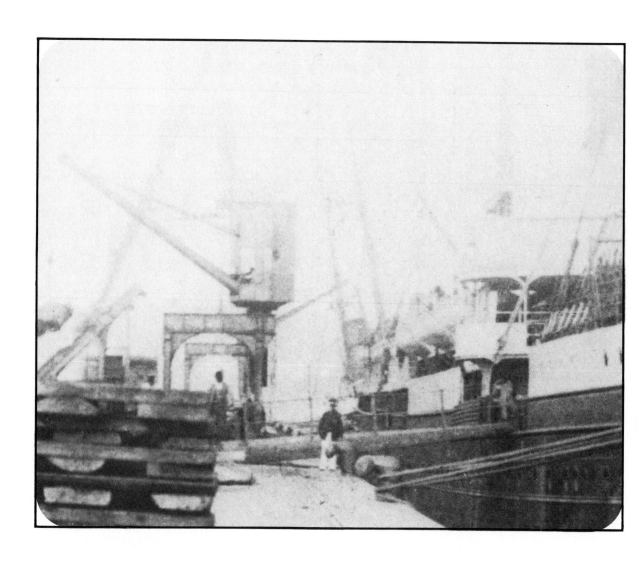

Occasionally, Lautrec would feel the impulse to travel. During the summer of 1895, he embarked on the *Chili* with his friends, the Guiberts.

Leaving Le Havre, they followed the coast to Bordeaux. Henri discovered a mysterious and ravishing passenger in cabin 24. She was feminine grace itself bathed in the high sun of July. Lautrec, smitten, pledged himself to follow this goddess to the ends of the earth. By Lisbon, he realized that his adventure was hopeless. He went ashore and returned once more, disillusioned.

In Spain, Toulouse-Lautrec found too many Carmens and castanets. But the Goya paintings sent him into raptures and he concluded preremptorily: "There is only one painter. . .and he is Velasquez."

At the end of the trip, he was seized by a kind of panic. Hastily he examined Madrid, then Toledo, sketched feverishly, and fled, returning home in as much haste as he had left. He was only thirty-one but he was becoming more and more unstable.

His vacation took him to Bordeaux and his old habits. Seeing him on a bench with Paul Guibert, one can already notice in his whole attitude a fatigue and a physical deterioration, accompanied by moral dejection.

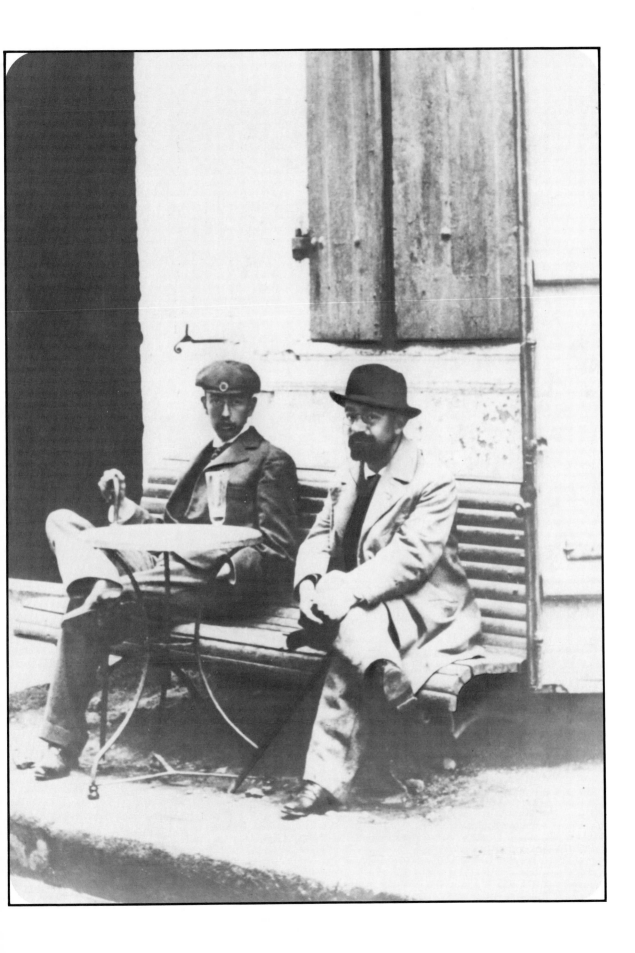

Using his inseparable little cane as an imaginary fishing line, he casts into the pond at Bosc or at Malromé.

On the same pond, he would amuse his little nephews by producing the colors of the prism with water droplets on the leaves of water lilies. He was a joking, teasing uncle. It seems that the parade of noisy children put a sort of isolating wall between him and his moral distress.

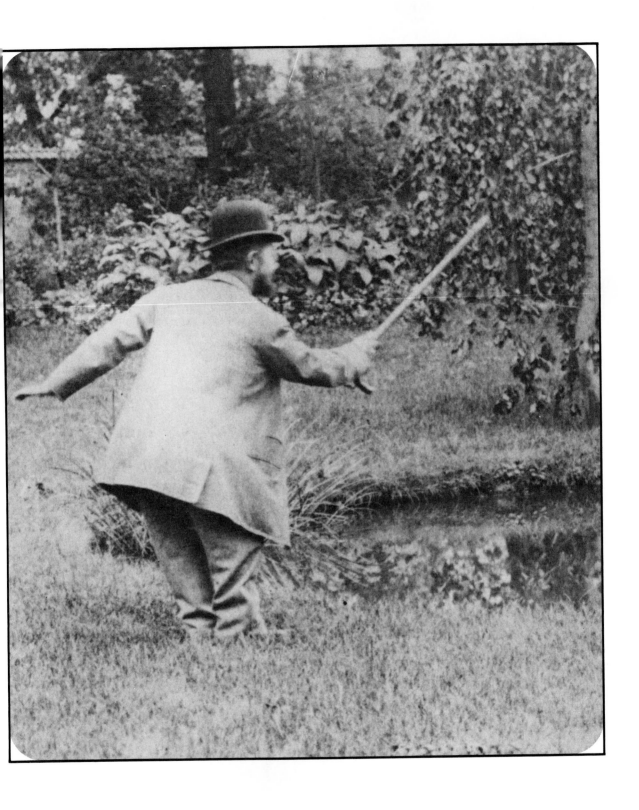

Lautrec started drinking because he liked
it, and because he was a bit of a glutton,
despite his refined taste and
connoisseur's palate. Also he wished to
fit in with his friends and their "Paris by
night" lifestyle which had so much
influence over him.

There is rest and "pastis" on the terrace
at Malromé, Lautrec slouching in an easy
chair across from his mother. On her
face can be seen an infinite sadness. She
had long given up lecturing her son, but
she knew that he was killing himself.
She had to be satisfied with giving him
an easy life near her, providing him with
the comfort to which he was not
insensible. Next to each other on the
little garden table are two glasses: for
her, a fruit syrup; for Henri, the
dangerous "baby" bottle.

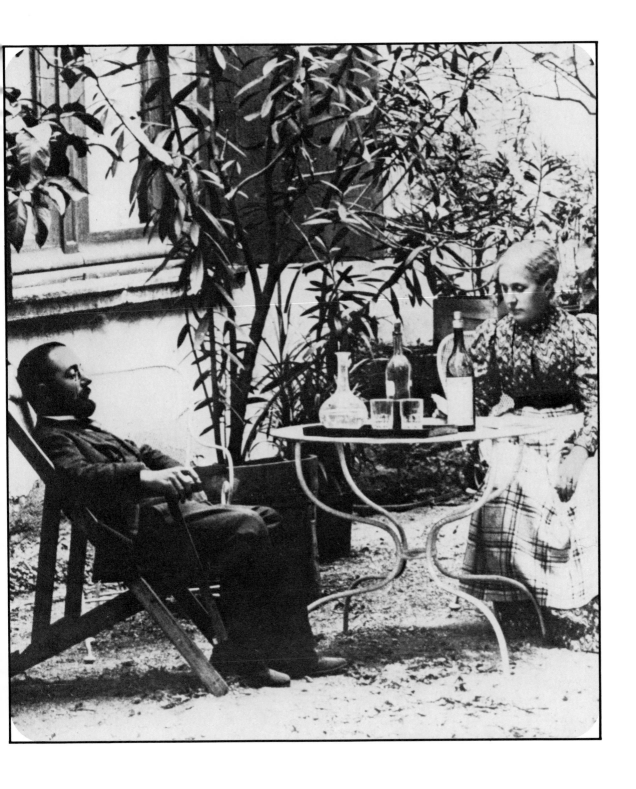

Henri held his liquor well until 1896, but then he began to lose control. His companions found him nervous and irritable. Naturally even-tempered, he began to provoke arguments with his cutting tongue and then, after the excitement, to fall profoundly asleep. "To drink little but often" had been his motto. Now he was drinking often . . . and a lot.

From 1895 to 1898, he made numerous trips both near Paris and abroad. He also went south to spend summers with his family, enjoying delicious meals and his relatives' cordiality, and entertaining everyone with lively stories and witty conversations.

He began to take walks in the countryside with his family, a healing balm after the consuming poisons of his life in Paris.

At the farm of the Château du Bosc, in the stables, he lapses into *patois*, a southern dialect, with those who remember his birth and still call him "Monsieur Henri." The old groom Pierre Grèzes, who had taught him to ride, wrote tenderly moving letters to him in Paris.

Beneath the high tower of Bosc,
Toulouse-Lautrec threatens the bulldog
Tuck with an "injection" while his
grandmother, the Countess de
Toulouse-Lautrec, and his uncle, Tapié
de Céleyran form part of the scene.

Lautrec's grandmother, uncle, and Tuck
are all subjects in his art.

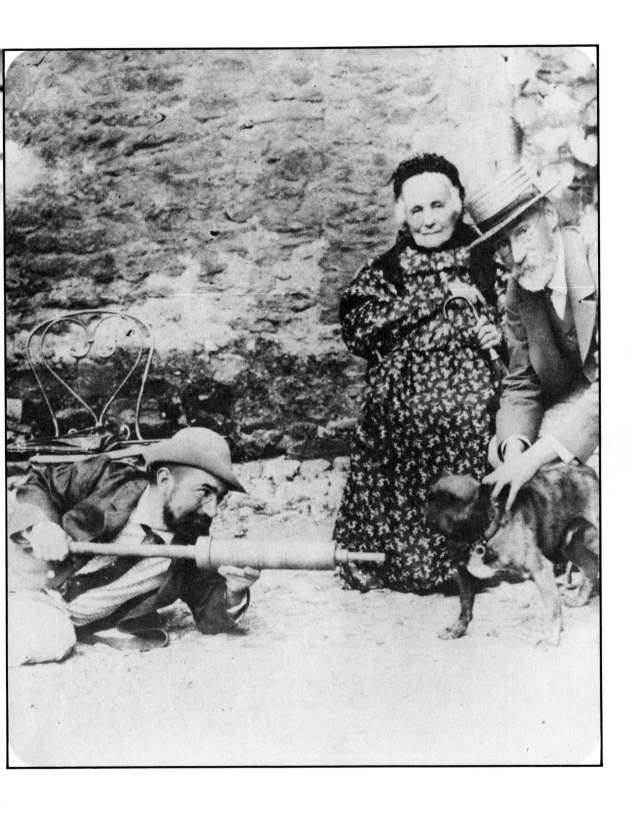

In the blazing summer of 1896, Lautrec
perches before the chapel of Bosc
sketching his first cousin by marriage,
Mme. Emmanuel Tapié de Céleyran. The
slim young woman's fiery hair has
prompted his nickname for her, "Golden
Helmet." Dressed in white, she poses
with an immense tulle ruching around
her neck, while Dr. Tapié de Céleyran
jigs to amuse her. Amédée Tapié de
Céleyran, one of the first French
automobilists, seems to be wearing a
dust-coat as he bends over the painting,
visibly interested in his nephew's work.

This little scene, familial and cordial,
hints at the pleasant interludes that
could come when Lautrec deigned to
remain sober.

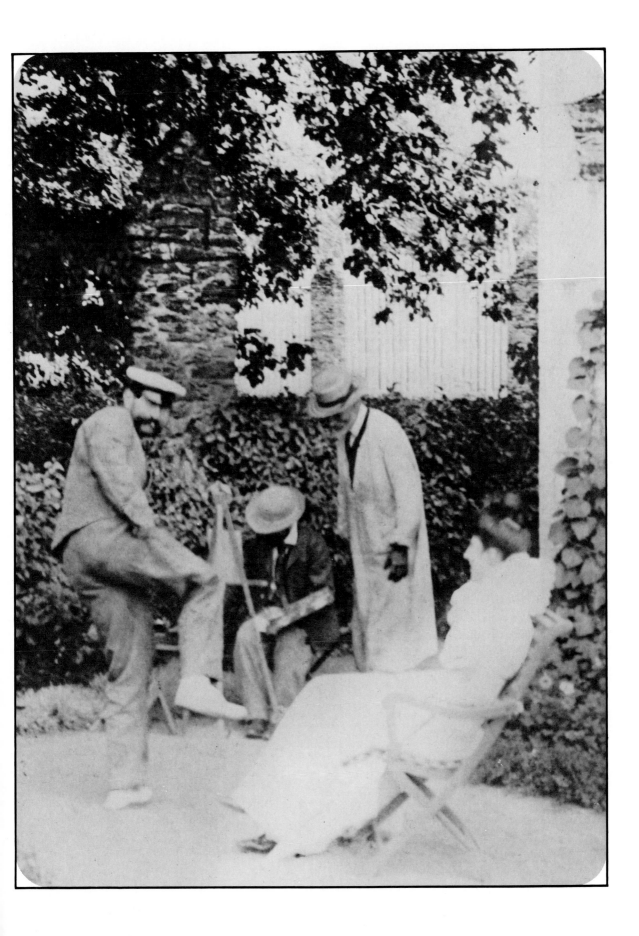

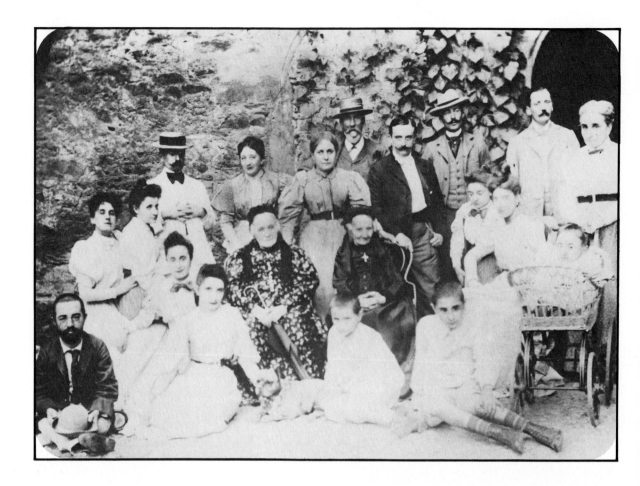

At Bosc, Lautrec poses for a family group portrait, front left, with his two grandmothers, his mother, some cousins, his uncle and aunts, and the Count des Cordes, and Louis Pascal, (third from right with white hat) of whom Lautrec will do the magnificent portrait presently at Albi Museum.

This photograph, taken May 1898 on the *Queen Victoria*, shows Toulouse-Lautrec crossing the English Channel to organize his own exhibition at London's Goupil Gallery. Hopes that separation from France would cure him of his pet vice were vain. Londoners drank even more than Parisians.

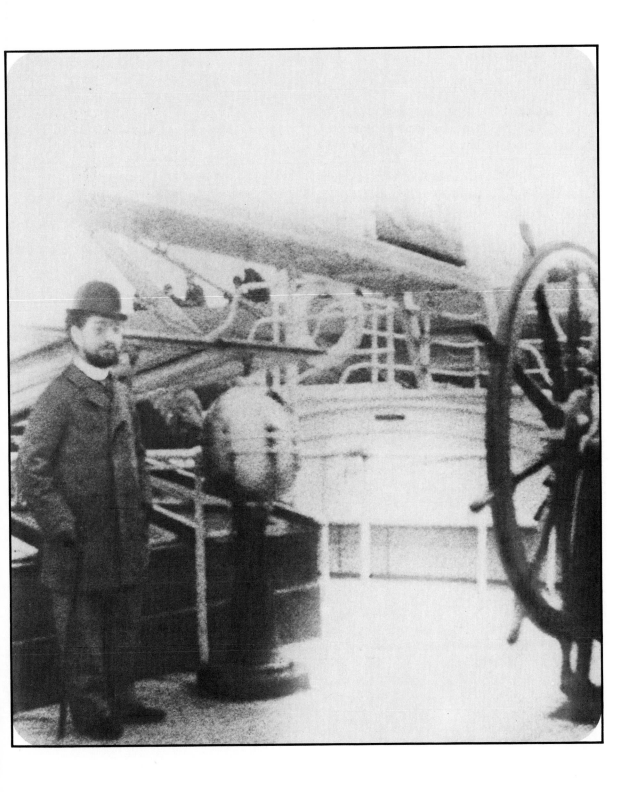

Alcohol, combined with his normal lack
of self restraint, had given Henri the
habit of falling asleep without caring
where he was.

At the opening of his exhibition, the
Prince of Wales and Princess Beatrice
passed in front of him. He was asleep.
Their Highnesses stopped and smiled . . .
and asked that he not be awakened.

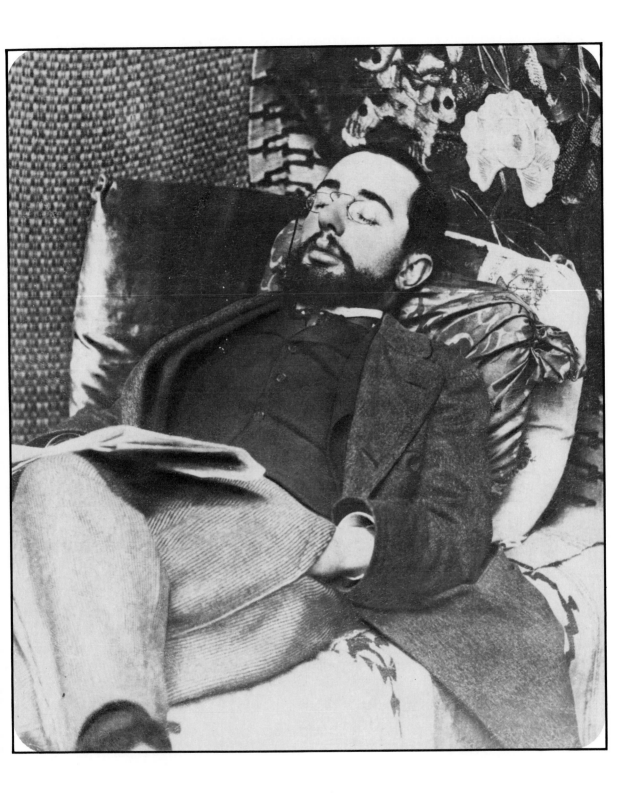

123

For his journeys, Lautrec adopted his own peculiar style of dress: a yachtsman's cap for the boat, red flannel pants from the fishermen of Arcachon, and a funny canvas bag that had become legendary. Besides his toilet articles and a few personal knick-knacks which never left his side, he carried his painting and drawing supplies. Also a bottle of cognac or rum.

The young painter loved Malromé, his mother's great house, where both pose with favorite dogs. There Lautrec felt truly like the head of household since his father was never present. He would invite his friends there often. Nature didn't interest him much anymore. He said his trees looked like "a dish of spinach." About the Mediterranean he said, "Better not to try it."

But he was attentive to anything that animated the countryside, and all animals fascinated him. He showed a veritable tenderness for them, pity for their sufferings, and limitless admiration for their intelligence. Like his parents, he surrounded himself with favorite dogs. He studied them closely, and used them as subjects for his illustrations of *Les Histoires Naturelles* by Jules Renard.

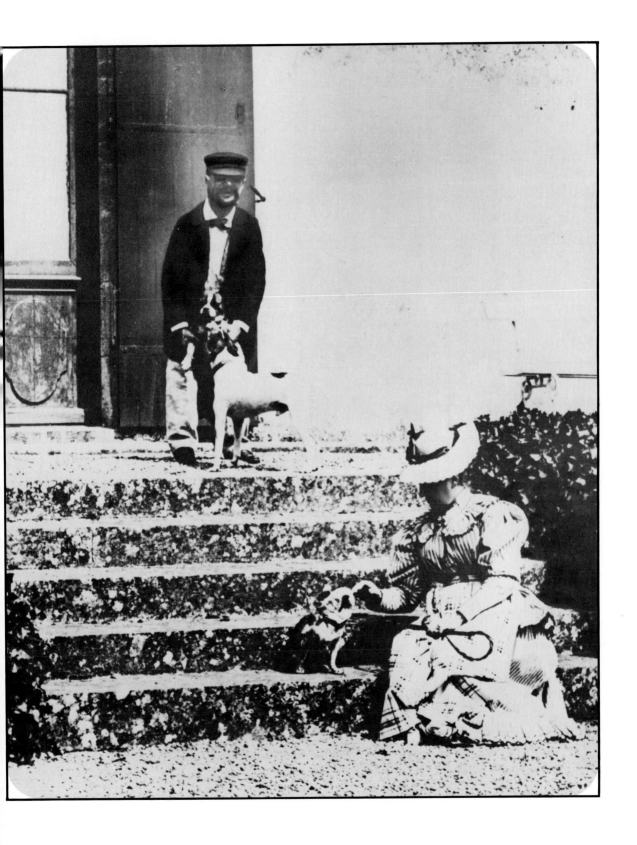

Henri's love of travelling grew into a kind of obsession. He would settle down comfortably in first class and fall asleep as soon as the train began to move, rocked into nirvana. At each stop, he would wake suddenly, ask for liquor, or go into the station for a drink. His childlike joy at the outset of a trip dissipated quickly into fretfulness. He was no sooner "en route," than he wished to have arrived already.

Lautrec began to spend more time in cabarets and bars, unable to concentrate on his painting. For a diversion, his friend Joyant lured him to Crotoy for some boating.

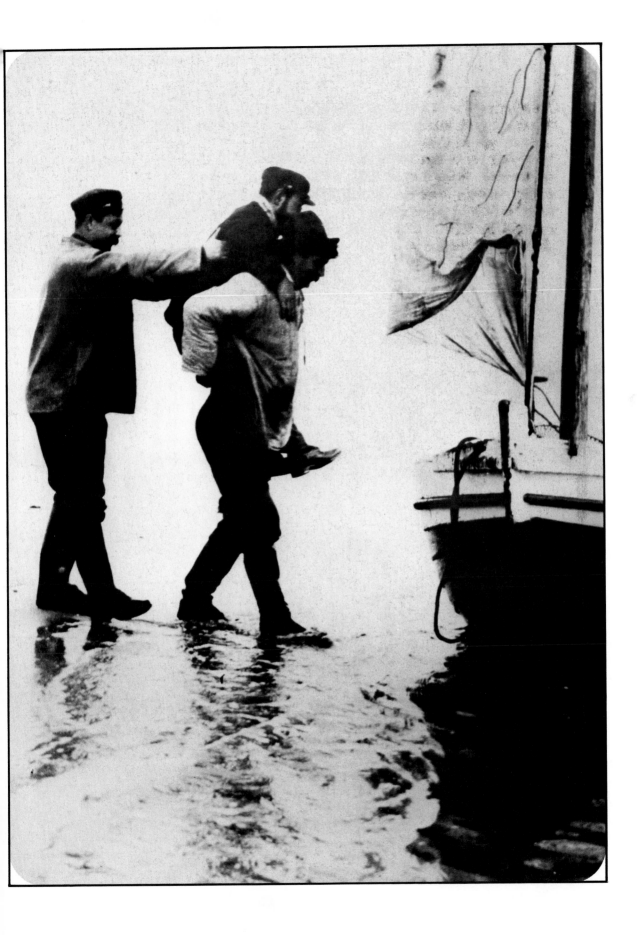

His alarmed friends, Maxime de Thomas, Maurice Joyant, bearded, and his cousin Gabriel Tapié de Céleyran, laid plans to try to save Henri. But he shunned salvation and threw himself with all his might into even worse excesses. Others stronger than he would not have endured this regimen of strenuous vice and full-scale dissipation.

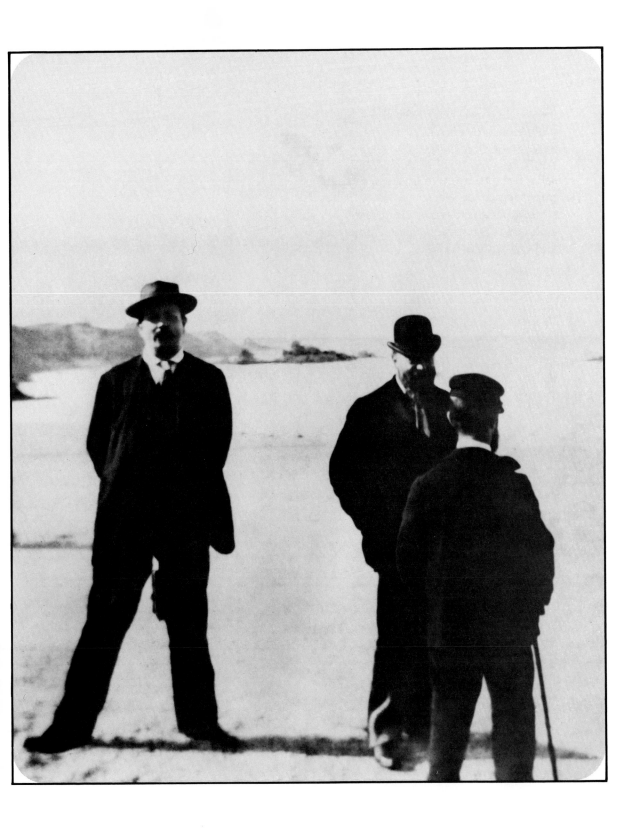

At the dike at Etretat with the Thadée
Natanson household, Lautrec stands,
legs spread like a sailor's, to regain his
equilibrium, regarding the beautiful
Misia, Thadée's wife, as an inaccessible
work of art.

"Get down, girl!" he would cry each time
he met a pretty girl who only gave him
affection and pity.

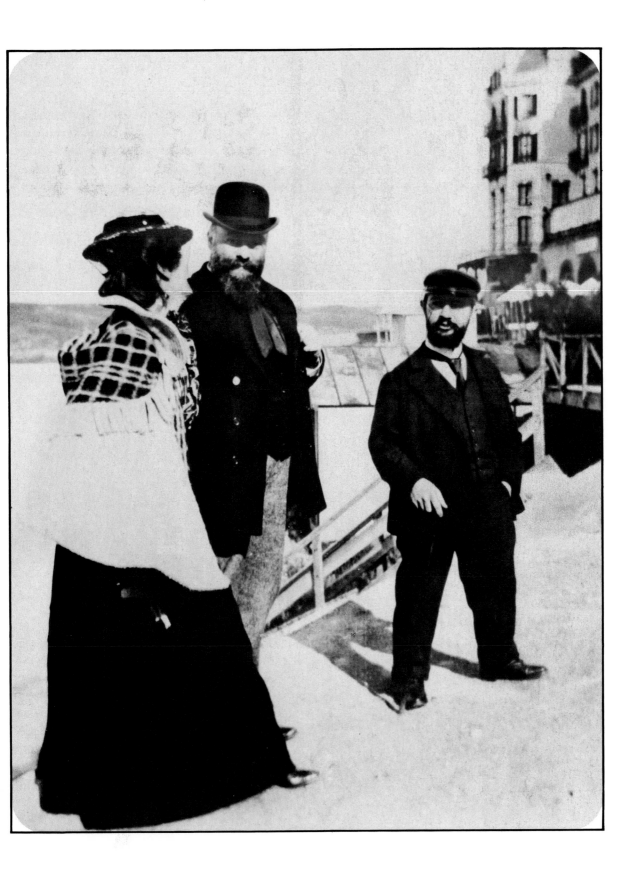

"Those who say they don't give a damn really do give a damn, because those who don't give a damn don't say they don't give a damn." It is odd how well this saying, which he occasionally repeated, suited him.

Here he drags himself painfully up the steps at Mont Saint-Michel on another outing organized by friends who wished to pull him out of his miserable decline. He found walking becoming increasingly painful, yet no one ever heard him whimper or complain.

134

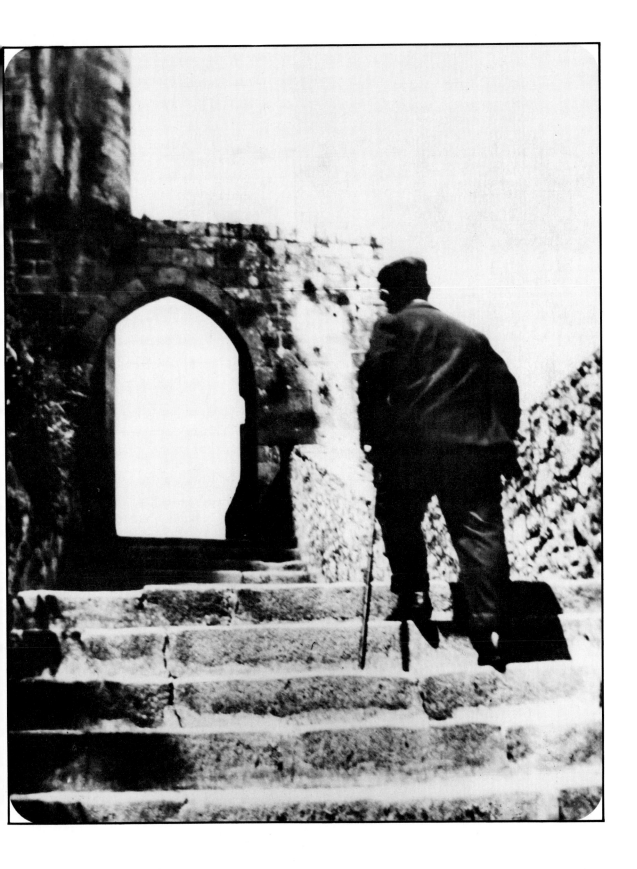

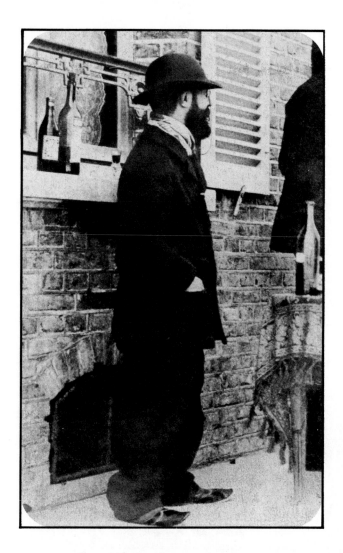

Henri steadily rejected the advice being lavished on him. He knew well enough that he was destroying himself. So did his mother. But she would not even hear of permitting him to be interned.

Then came a crisis of such hysterical violence that there was only one solution: a convalescent home. Doctor Semelaigne's clinic Chateau Saint-James, in Neuilly-sur-Seine was chosen. Lautrec was taken there in February 1899.

Deprived of his favorite poison, and nourished by excellent care and good food, he gradually had fewer violent deliriums and terrible hallucinations. The grounds full of flowers and shade revived him. Violent and stupefied for the first few days, he regained some equilibrium there, received visitors, and took up his painting materials and pencils.

Meanwhile, jealous rivals and the sensational press, always on the lookout for scandal, made a great commotion over his "madness." He refuted them totally by painting a magnificent picture from memory and without a model: *Le Cirque (The Circus)*.

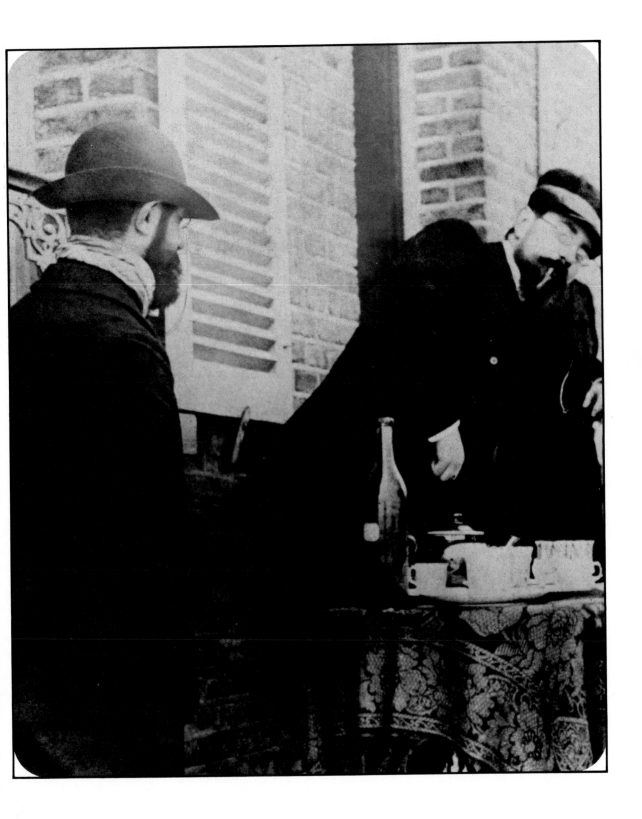

After two months of detoxification, Toulouse-Lautrec was released on 17 May 1899. He began working immediately, then interrupted himself for a vacation. Upon his arrival in Le Havre, he discovered "Le Star," a cabaret where the barmaid held his attention for several days. In contact with her, Lautrec found his inspiration again.

For a year or so, Henri remained relatively sober, happy to have left the Chateau de Saint-James which he called his "captivity." But slowly afterwards, he took up drinking again. He had neither the wish to save himself nor the moral energy to resist alcohol.

In May of 1900, literally dragged by his friends to the Bay of Somme, he did a beautiful portrait of Maurice Joyant at the hunt.

Yet seated in a boat, Lautrec's appearance was frightful. Swollen, mouth sagging open, more slouching than ever, he seemed like a package carried about by his friends.

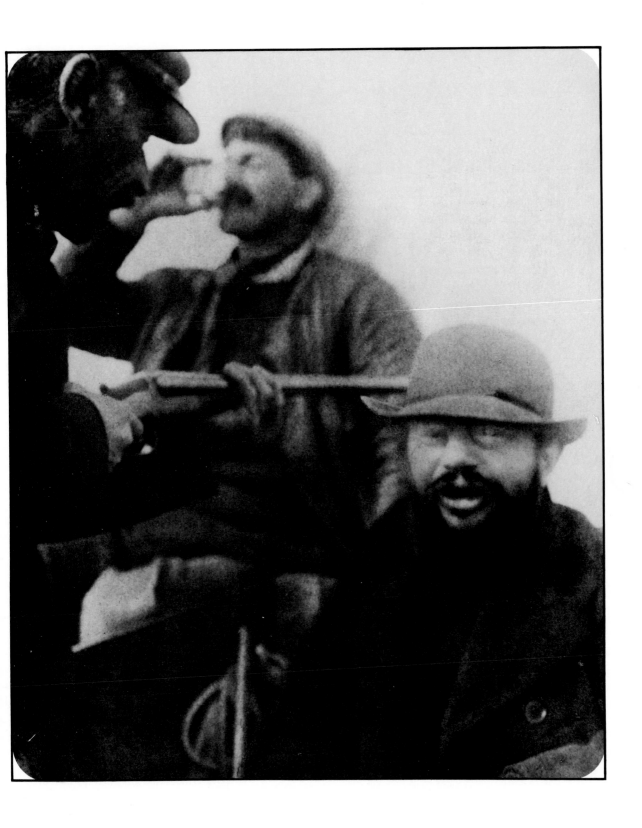

Here Henri daydreams in front of the great canvas of the *Ballet of Chilperic* where Marcelle Lender dances her bolero.

The theater was, for him, an inexhaustible mine of inspiration— limelights brightening faces from below, this or that painted face standing out near the boxes, a walk-on actor in the foreground leaving other actors in shadows. Of such material did his spirit and verve make masterpieces.

During 1900 he worked ragingly in his studio on Avenue Frochot, on posters and portraits of friends, including the remarkable one of the pretty Mademoiselle Margouin. Before leaving on vacation, he would isolate himself and hurry as if his days were numbered, attending to unfinished business, completing preliminary sketches, signing his works as a sort of testament for posterity.

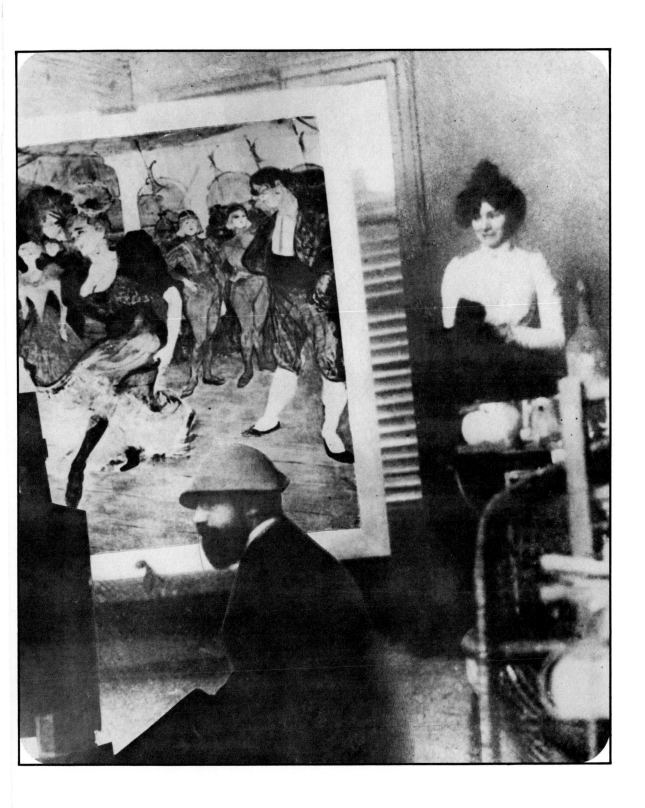

Dragging his feet, Henri de Toulouse-
Lautrec goes off once more, God knows
where, carrying the nostalgia of his past.

For the last time, Henri fled Paris, complaining that it bored and tired him. At the end of his life, he conceived a dislike for the great city he had loved so much, and for which he will remain eternally the great chronicler of his period. The exile came to Taussat again. The final act was near.

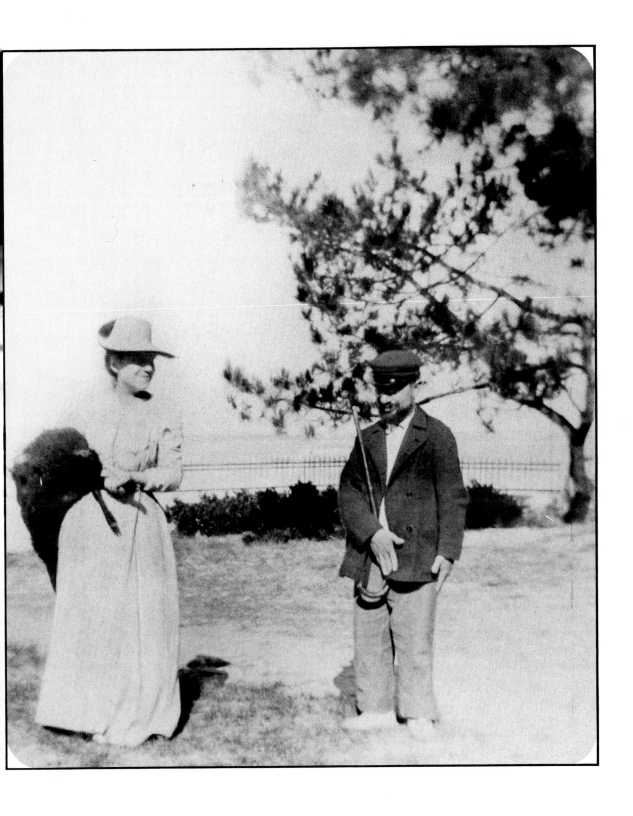

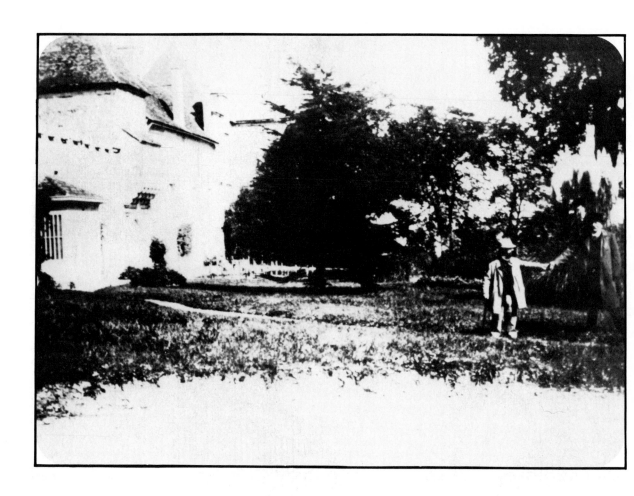

In the peace of summer's end, 1901, Henri fell stricken by an attack of paralysis. His mother took him from Taussat to Malromé, surrounding him with marvelous tenderness. Here he takes few steps about the lawns of the castle, supported by a charitable hand, but the peaceful atmosphere could not give him back his strength.

Lautrec made some leisurely outings by carriage, as his legs would no longer support him, and spent hours in a chaise lounge on the park terraces. Feeling death approaching, of his own accord he asked for a priest. Soon, he would no longer leave his bed.

146

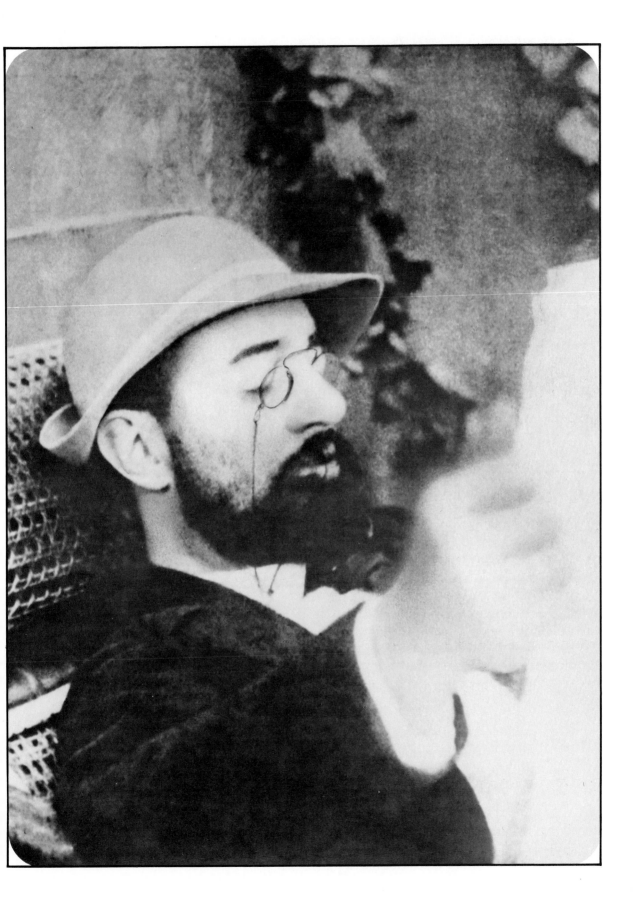

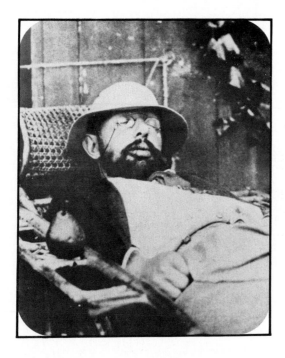

The brush has dropped from the adroit hands which, till the very end, worked on the portrait of Admiral Viau in a final surge of declining energies.

His last words, after the cry of love to his mother, would be: "It's damned hard to die." The curtain fell 9 September 1901.

It was a hard passage toward the shores of the next world, but harder still, perhaps, was the farewell to this fine, mean, horrible, and lovable thing—life—in which he tasted the worst and revealed the best.

His mother's despair was softened only by her prodigal's return to her and by his death in her arms as a Christian.

Count Alphonse was overwhelmed with grief at "the terrible end of this pitiable child of destiny." To a friend he confided: "Who suffered more, the father or the son? Of the two of us, he suffered most because he was *humiliated*. I myself had nothing but moral torture, constantly reproaching myself. . . . My paternal pity was cruel, continuously growing, far from being dulled by the artistic successes of my poor child or the incense offered by warm admirers."
(Letter to M. de Lapanouse, 12 September 1901.)

He is almost a corpse already; his face is clothed in the majesty of approaching death. Upon the armrest of the chaise lounge, pious maternal hands have placed an autumn pear, creating a still life next to one who will always be thought of as the "painter of life!"

Unable to deal with alcohol or women, Lautrec made bad use of both and burned up his life. Upon his shrunken shoulders lies the weight of an existence he had not chosen. The pain which he felt more acutely than others less sensitive than he, and the sporadic flashes of incomplete satisfactions which sparked only to go out, left him in resigned bitterness.

How better to conclude than with the judgment of one of his closest friends, Louis-Numa Baragnon, who wrote on the very evening of Henri's death:

> Because he was small, ugly, paradoxical, singular in every way, the people of Paris, hasty and superficial in judgment, have composed an abbreviated conception of Toulouse-Lautrec. They have made him the prisoner of a formula. Words like *gnome*, *dwarf*, and *bohemian Montmartrois* fell easily from the pens of these necrologists. They only expressed one side of this misunderstood nature, which remained, despite so many humiliations, noble of heart as well as of birth.

> Toulouse-Lautrec was a being of power and truth. He abused his power to the point of ruining his health and died, not mad but worn out, at the age of thirty-seven. His truth rises out of his paintings, his posters, his drawings and his engravings. As soon as this student of Bonnat and Cormon had discovered Japonism, he knew his path. His striking intuition aided by his constant labor transformed itself into a new synthesis. With a passion for exactitude, he too often accepted mankind in its lowest manifestations, but those who have contemplated his Phaedre and Oenone, his portrait of Dr. Jules-Emile Péan, those horse-racing scenes, know with what fervor, when he was vanquished by her, he could sense Beauty and render her.

> This artist doubled as a laborer. To perfect the technique of his art, he even worked in stone; lithography owes him several innovations. Already zealous collectors seize upon the best of his work. The curious who would like to know him better would do well to dismiss the anecdotes and simplistic reports, and to re-read an article in *Le Figaro*, May 1899. Rarely has criticism demonstrated a more thorough knowledge of its subject. It is already a cliche to say that the name of Toulouse-Lautrec will have its place in the history of French art, *mutatis mutandis*. He is our Goya.

> Even those who, more moralists than artists, will criticize the character of his inspiration, his predilection for the grotesque, his extreme whimsicality, will never deny the essential quality of his art: style! And of no one is it more true to say that the style was the man.

September 1901

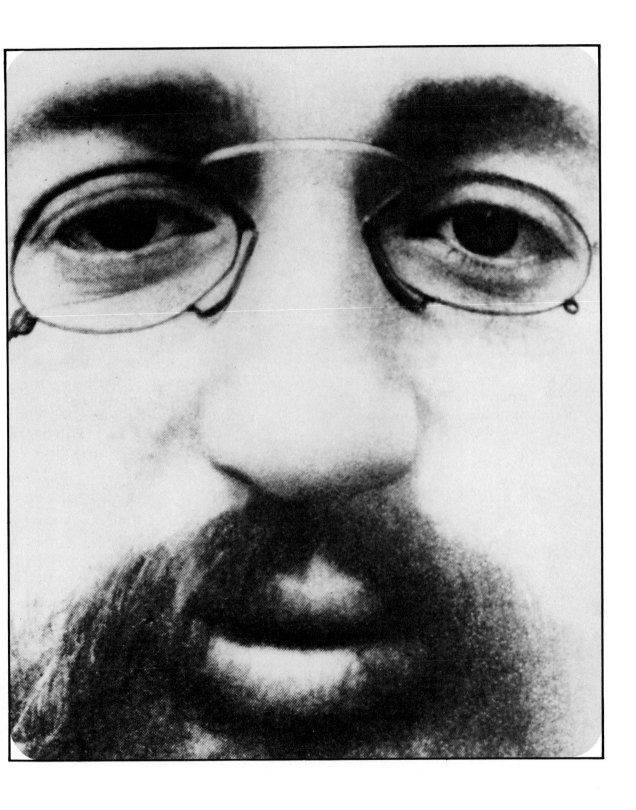

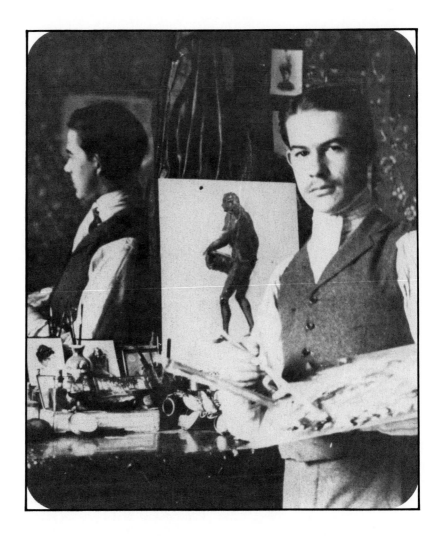

*Robert de Montcabrier during the time when he*
*worked at Lautrec's studio on the Avenue Frochot.*

## Epilogue

Tristan Bernard, learning of the death of his good friend, Henri de Toulouse-Lautrec, exclaimed, "Behold Lautrec, restored to the supernatural world."

Georges Beauté has brought Toulouse-Lautrec to life, showing him through a magnificent use of photographs from his birth to the end of his life—among his models, his friends, the family he loved; near the mother he idolized and the father he

**153**

I would not compare Lautrec to an abstemious Puritan, nor deny to Count Alphonse a certain amount of the originality which was his birthright; but it would require pages and pages to recount the truth about the conduct of the painter and his father before all the stories which have burdened them could be laid to rest.

Having had, during my adolescence, the privilege of visiting the studio of my cousin Henri on Avenue Frochot, I could say that I worked under his eye. He guided my first steps down the perilous road of the fine arts from the end of 1897 until his death in 1901. Thanks to this fortunate relationship, I discovered that he himself was in great part responsible for his own reputation and had authored numerous tales about his own life. He would be overcome with joy when these legends found their way back to him or when he read them in print, amplified and transformed.

I remember the day he moved from his old studio on rue Caulaincourt to the new one on Avenue Frochot, aided by a modest two-wheeled, horse-drawn vehicle. Lautrec, who was following on foot with friends and movers, exclaimed, "We look as if we are following a funeral." This sally of wit was transformed into the public rumor that he had rented a hearse to move—as if the very proper Borniol Mortuary would have rented a hearse for any other reason than to carry the coffin of one of those great men who are followed by a black-clad "gentleman of the family," wearing a top hat and short breeches and carrying an ebony cane!

Lautrec, following the example of his father, made it a rule never to deny anything. My Uncle Alphonse, Henri's father, was an expert in inventing stories designed to shock

154

certain of his companions. He never, for instance, denied the concocted story concerning the Grand Duke which is recounted in many articles written by "well-informed" people and in other works about Lautrec. I apologize to the Lautrec biographers, but the Grand Duke in question was nothing but a carriage equipped with large springs. When Count Alphonse used to leave Paris, never knowing when he would return, he would have his carriage lifted a few centimeters from the ground by means of straps under the body of the carriage, attached to pulleys fixed to the roof. Thus the large springs would remain perfectly equal on both sides and the body of the carriage would not settle either to the right or left. This was a common practice with coaches at the time. For the incident in question, the man in charge of his stables and carriage house had probably informed his master by letter that one of the wheels of the carriage was touching the ground. Count Alphonse sent the famous message, "Save the Grand Duke!" That carriage was transformed by the magic wand of a mischievous fairy into the cousin of the Tsar of Russia at the very moment of tremendous upheavals in that country.

Why do Lautrec's biographers, who have not known him intimately, make so many improbable judgments? And why do they attribute to him such pessimism? Because of Lautrec's refined education beginning his earliest years, he always observed a flawless courtesy and impeccable politeness. I never heard him swear or use vulgar words in conversation. He totally lacked the experience of life in dormitories or in the army, which teaches such habits. Though he found some of the unusual and expressive slang words used by his friend Aristide Bruant amusing, he never brought them into the parlors of the dowagers and fine ladies. He could give tit for tat in language appropriate

to pestering fellows who considered him a Barnum circus phenomenon or who treated him with insulting condescension or who vaunted a pretentious superiority based on the additional inches of their height which permitted them to look down on him. I suspect that is why most of these "great men" waited for the painter's death to have literary revenge. They would have dared no such thing during his lifetime.

The pictures that Georges Beauté has gathered here show that Lautrec was not ugly as legend has it. Indeed, a multitude of his contemporaries, bearded and bespectacled, were much uglier. Very few faces and eyes showed as much intelligence and compassion as his.

The period of his life around 1899 was rather miserable for Henri and for the people closest to him. However, Lautrec was never the "degenerate" that some of the writers who have never known him claim. For example, it has been said that Lautrec had been losing his memory months before his stay in the clinic in 1899. Cited as evidence is an invitation to an exhibition that he gave in 1898. In it he indicated that the party would occur in 14, Avenue Frochot. What! He did not even remember that 14 was not his studio number? Of course he knew his own studio address. Failing to do their homework, these critics did not realize that the exhibition did not take place in his studio but on the first floor of No. 14 in a vacant studio adjoining his. I can vouch for this because I helped the custodian of the building carry down the works. We leaned

*Calling card written by Lautrec to his cousin, Robert.*

them vertically against the wall, the canvasses and drawings turned out, contrary to their usual position in his studio, where the painting or drawing was always turned towards the walls. There was never anything hung on the walls of his atelier on Avenue Frochot.

During Lautrec's 1899 stay in the clinic, his brilliant series of circus drawings is additional proof that his memory had not failed. Even on the eve of his internment he had not lost his sense of reality. We had arranged that I would go work in his studio with him on Sunday. Saturday night, I received his note cancelling the appointment and giving as the reason that the model would not be there. Since we usually lunched after these sessions at his mother's house on the rue de Douai, he forestalled my appearance there, either for lunch or to pick him up in the late afternoon to accompany him to town, with a little white lie: "Instead of the trip, I am painting a portrait in town." In other words, even between attacks he still had a perfect memory of his social obligations.

I never heard Henri criticize the works of his colleagues. Like any intelligent painter who is not overly conceited, who knows his trade well and is very eclectic, Lautrec recognized good qualities of other painters, even though he may not have liked their canvasses. His only theory of art, repeated frequently, was: "Each person has the right to paint as he wishes, and it's nobody else's business." It would be an error to see this as defensiveness about his own domain. When I first heard him repeat this phrase his

fame was growing and giving him extreme satisfaction. True, he sometimes had strong words for his colleagues, but he was aiming at the man himself, not the artist or his art.

On the other hand, he would not permit anyone to speak disparagingly in his presence of the painters he admired, those past as well as those contemporary. His favorites represented all schools, even those which appear the most contradictory.

Here I conclude these few reminiscences, among so many others, that my good and affectionate cousin has left me—my cousin to whom several famous writers were faithful friends despite his childish whims and fancies and whom they considered a delightful boy.

I should like to conclude with this obituary notice which appeared in one of the larger Parisian newspapers the day after the death of Henri de Toulouse-Lautrec in 1901.

> A name. A master who disappeared too soon; one of those rare ones who grab you and make you shiver. He was rich and free from the yoke of life's hardships. He could apply himself to observing life.

> What he saw is not flattering to his time, the end of the century, of which he is the true painter. He looked for reality, disdainful of the fictions and vain imaginings which falsify ideas and unbalance minds. Some would say, perhaps, that he was a nosy forager, a dilettante of originality but tainted with melancholy because of his ill health.

158

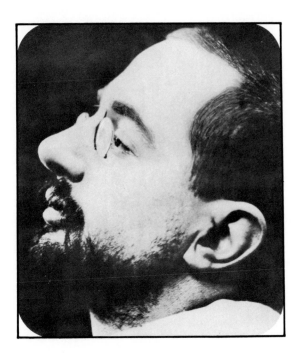

This is not true, and all his work testifies that it is not true. He did not forage, he did not strain himself to take where there was nothing. He merely looked. He saw not what we seem to be but what we actually are. Then, with a steady hand and a boldness both delicate and firm, he showed us to ourselves. Oh, it certainly isn't flattery! There is something for everyone here: grand concerts, public balls, theaters, circuses, coffee houses, wet horse tracks—all the places where the fever of living pushes men and women to hunt for any kind of pleasure. It is all here fixed forever by the pitiless pencil of the artist.

He made his own a genre of painting where others have also tested their talent. Made-up faces, flashy petticoats, tinsel at fingers and earlobes, fake jewelry, all the expressive signs of unfortunate girls who hide burning tears under pale smiles— Toulouse-Lautrec has shown us all that. He not only wanted to be a painter. He revealed himself as a profound and penetrating psychologist. His teachings are hard and sad, but true.

This is why the Master will remain the painter of an epoch that we know nothing of because we lived it as sceptics occasionally and almost always as careless and indifferent non-entities.

I can add nothing to these prophetic lines.

Robert de Montcabrier